THE
ARTFUL
DODGER

D0898445

Best Wishes,
Richard D. McMain —
KCOSA, KSMA —
Note: Unedited &
un-revised copy!

THE
ARTFUL
DODGER

Collecting and investing in fine art without a spare million in pocket change

Leonard D. DeMaio Ksma,KCosa

Outskirts Press, Inc.
Denver, Colorado

The opinions expressed in this manuscript are solely the opinions of the author and do not represent the opinions or thoughts of the publisher. The author has represented and warranted full ownership and/or legal right to publish all the materials in this book.

The Artful Dodger
Collecting and investing in fine art without a spare million in pocket change
All Rights Reserved.
Copyright © 2010 Leonard D. DeMaio Ksma,KCosa
V4.0

This book may not be reproduced, transmitted, or stored in whole or in part by any means, including graphic, electronic, or mechanical without the express written consent of the publisher except in the case of brief quotations embodied in critical articles and reviews.

Outskirts Press, Inc.
http://www.outskirtspress.com

ISBN: 978-1-4327-5249-1

Library of Congress Control Number: 2009942467

Outskirts Press and the "OP" logo are trademarks belonging to Outskirts Press, Inc.

PRINTED IN THE UNITED STATES OF AMERICA

TABLE OF CONTENTS

Philosophy ... vii

Dedication ... ix

Introduction ... xi

Chapter I: In the Beginning, Prologue (the learning curve) 1

Chapter II: To be or not to be a Great Collector and who's collecting ? 7

Chapter III: The Problems of Collecting. How to Become a (Serious) Professional
 Private Eye .. 15

Chapter IV: Field of Dreams? Hell, focus on first base! (Schools, Styles, Periods
 and Movements) .. 29

Chapter V: Where and Where Not to Find Fine Art "Or the games a'foot Watson" 33

Chapter VI: Methods of Collecting (also accumulating cash) 61

Chapter VII: The Legend of de Kooning, Thelonious Monk, "tripping with" eBay
 and Dead Case Tales" .. 73

Chapter VIII: Art for Adolescents (OK, Grown-ups too!) 87

Chapter IX: Traveling Auctions, "Road Show", Anatomy 101, History 95

Chapter X: Graduation, "Pass In Review" .. 107

Certificate of Revelation .. 115

PHILOSOPHY

Afraid of starting a fine art collection? You haven't got a spare million tucked away?

You're not even sure what's good or bad art or even where to start looking?

Besides "arty people" are such snobs and they scare you away! Then accompany me in a serious, however light hearted approach to understanding those mysteries of collecting fine art! In doing so we will expose some of those "great collectors". Next we will provide and demonstrate those techniques that will allow you to collect fine art for less.

Unbelievable? Not really because this book is based upon fact and not fiction. I know because I have successfully collected millions of dollars in authenticated fine art–most for a small percentage on the dollar. I repeat, this book is written for the beginner, especially those who haven't a spare million in pocket change!

Now take notice, we will mention specific areas, galleries, and people based upon personal experiences. In other words no ambiguity here! We tell you: What, where, and when to collect. The only disclaimer noted, is that they are offered as a best effort offer, with no guarantees. The prime motivation is to advance beyond that first universal rule of collecting fine art, so often presented as a defense mechanism by art dealers. Reiterated, the forlorn buyer usually parrots this phase.

"I've purchased this work of art because I like it." Accompanied by the following distress questions: I hope I haven't paid too much? or, I haven't a clue why?

Yes, that "like it" routine, usually is the dealers last line of defense, and it's a killer! Never really providing any practical information or compensation. By contrast the function of this "how to" manuscript, is to provide simple stepwise explanations moving you beyond that "trumpeted" first universal rule.

DEDICATION

This book is dedicated to my parents and grandparents. They advocated tough love and honest effort. My hard working father, whose education ended in the eighth grade with the death of his mother. Sent to work to "help support the family." In spirit and will he had no equal. My brilliant mother. Ada, especially my mother. She always nurtured the gifts of art, music, books, and literature. In retrospect an original perceptive scholar! Decades ahead in fully understanding: politics, religion, feminine issues, the environment, and even the potential dangers of atomic energy. Together with the central importance of family and culture. Dedicated also to the tragic loss and memory of my precocious younger sister Lois, while pursuing her doctoral studies at Brown University and the Sorbonne. My immediate family, Rusty (wife), Robin, Leonard, and Laura. All educated and successfully contributing members of society.

These last words are reserved for those honest toilers and lovers of the arts. Those teachers, students, curators, collectors, and supporters. Seldom are they financially rewarded or appreciated. Care not as you are often shunted aside, for the popular "half genius" of the day. Yours is the realization that Gods' way of speaking to humanity is through the creation of the arts: Music, art, literature, theater, and dance. You are the blessed!

I leave you with these words of encouragement. Time permitting; there is never an honest task to turn away from,

There is never the concept of old age, if you're young at heart,

There is never a horizon too distant, when you realize that the real journey doesn't begin with a simple step, but with an original thought, and the measured distance between a strong heart and mind.

Leonard D. DeMaio,KSMA,KCOSA

INTRODUCTION

How To; Baby Steps

Confucious said: "A journey of a thousand miles begins with a single step." BIG DEAL! In which direction? Right or left? Up hill or down? Above or beneath water? As noted even the simplest statement may create additional problems.

Here is a simple fact of life. You've already taken the first step by reading the above paragraph. Now go ahead and purchase this book and allow me acquire some royalties. If your bright (second step) you'll learn a thing or two about collecting fine art!

Philosophy Lesson

Now the hard stuff, also known as the "Real Deal". People do things for a few basic reasons: Need or greed, love or hate, power or prestige! End of lesson! Wait, have you purchased, this "tome" yet? See, that's my greed speaking—I never said education would be cheap!

Brave Hearts

Stand fast. Forget those investing magazines that proclaim; you have to spend

millions of dollars, even thousands, cataloguing and assembling a fine art collection. Near the end of my laborious writing effort, which began three years earlier, a "chi chi" investor's magazine ran an interesting article on collecting fine art. The premise expounded was: "fine art is the greatest long term investment of all time". No argument there! The "flawed" problem with their presentation was that it began with expenditures of millions and millions of dollars. This concept pre-conditions you to the idea that it is impossible to even place your foot in the door! Please, those editors need a "grip on reality". Granted that old and some new masters are out of the question, well it's still a "big ocean". Dismiss those headlines that are created for spectacular reading. Over-looked is the fact that few if any could collect with that premise. Fewer yet, as the article promoted, would be able to hire private dealers, or curators to do so!

We are here for the "novice collector", those "Brave Hearts"! Americans are both a creative and resourceful people! If we can construct additions on our homes, certainly with considerably less effort, find and hang fine art on our walls!

We accomplish our artful task by:

- Analyzing the competition and asking: Who are these great collectors? Are they "true blue champagne and caviar", or really a glossed-over "beer and pretzel" species?
- We de-mystify in plain English, purposely using every clichéd quote "known to mankind". See I've started already! Here's a more pertinent example:"He is the next great (unknown) artist". Now there's an oxymoron!
- We examine and delve into the routines of those traveling auctions. I refer to them as "road shows".
- We discuss the importance of records provenance and condition. Together with selected fraud techniques such as "Aged in Havana".
- Explaining to the "best of our ability", what and what "not" to collect. Best bets are indicated with a dollar sign ($).
- Finally we provide methods, techniques, and areas to search. Here timing plays a major role. These concepts may also be indicated with a ($) symbol or underline

for <u>importance</u>!

- "Boxed off" is the word <u>"Revelation"</u>. I chose the word "Revelation" to illustrate and define the meaning of truths, common sense, realities, and irony, as applied to fine art. After, the mini-series aired (Revelation), the thought occurred to me to insert, or use another biblical word like "Epiphany". Pondering my luck there could also be a spin-off series with that title, so revelation remained.

CHAPTER I

In the Beginning, Prologue (the learning curve)

From the time I was a wee infant, I loved to collect "things". All kids do! If I found two similar rocks, I thought I had located "King Solomon's Mine". My mind ablaze with buried treasure, and typically going beyond the curve, I dug up half of the back yard—before my mother fortuitously stopped me. I wasn't allowed to play in the front yard, for some reason that escapes me, even today! My frustrated mother categorized me either as a pack-rat, or born collector. I'll air on the side of collector, because it has a more sophisticated "ring" to it! This fact was self acknowledged by my eighth birthday. I was hopelessly addicted to collecting.

Early on I had assembled one of the greatest collections of T.V. and "box top" offers, in the free world. That's my free world, which extended to the end of the street. It was my father who taught me the value of a "buck". If he gave me one, I had better have change left two weeks later, or he thought I was keeping a woman—quite a feat for an eight year old. Spend wisely! Then something happened—the "Revelation" came. What I did for love also brought me a measure of fame. Soon kids were traveling from distant lands, beyond my street corner, as my reputation and collection grew. They came from broad treed avenues and lived in large houses, with huge picture windows.

I knew this for a fact, because those picture windows were "lighted" all night. This much to my father's dismay and cursing. He was adamant about (not) making the electric light company rich! On a more personal level, I had pocket wealth and peer adulation. I was number one, "King of the T.V. and box top offers". Everybody loves a winner. "It was good to be King." End of revelation.

<u>Lets Get Serious</u>

A reminder that this labor of love is based upon fact and not fiction. For the past thirty years plus, I have successfully collected millions of dollars of authenticated fine art. The important lesson for you to digest was that those collecting efforts were assembled during the apogee of the richest art and auction market in history. It was the "best of times" for sellers, and the "worst of times" for collectors. Did I mention my collecting was accomplished on a teacher's salary? That's why I know you can do it too!

Immediately upon entering my chosen vocation—education, I was confronted with the sad realization that the expectations of even an average salary was beyond hope. My educational studies resulted in five certified majors: music, education, history, social studies, and art. Three degrees (everything except a doctorate) and four national awards and research grants. The pain of remembrance also revisited the fact I had turned down two "blue chip" business offers. These had an initial salary at least five times more than a teacher's salary. Not withstanding my current financial arrangements, collecting fine art seemed like an impossible dream. Often blatantly reinforced by every published article surveyed. "It's a rich mans game" and I was the "vanquished majority" until that fateful day.

Totally by accident, I chanced upon a local auction houses' advertisement. Later that evening, sitting in stunned amazement and wide-eyed attendance, two things crossed my mind. First the wonderful art being offered and next the terrible pieces being "bided" up by the "*chichi*" audience. All of the wrong pieces—the "fluff stuff". Stunned and captured in the moment, I began bidding—Lord Almighty, guess what? I won! Yes, I had won! Having successfully secured a signed and numbered (S&N), catalog limited edition graphic by Henri Matisse. My total cost was around $180 dollars. I was amazed—I won a Matisse!

Where was the competition? Had I scared them off? Was it my display of exuberance and eagerness? That really puzzled me! Reflecting upon that scene over and over again, not even realizing then that a crack in the dam had appeared. That innocent moment would unleash the flood gates of collecting, and significantly alter my life style!

CHAPTER I

I couldn't free myself from the reality of the moment, driving home that evening. I had successfully purchased a real catalog listed, hand signed, limited edition, Matisse graphic–in mint condition! Again also imprinted in my minds eye, were the other great pieces left behind. A transient thought flashed through my grey matter. More for me to pursue, yes to collect! The second part of the equation also troubled me. Why were those other super pieces left behind? I had recognized and noticed some "well heeled" people in attendance. Cultured and rich by appearance. If need be, they could of smothered my bidding efforts. The first serious doubt crossed my mind. Rich, however, culturally knowledgeable? That raised a "red flag", and I needed a new perspective!

Recollecting my average middle class childhood, we owned our own house and car by the time I entered Junior High School. Memories of great classical and jazz composers and performers filled the rooms. Ellington, Basie, Goodman, Krupa, Miller, and Armstrong, battled with Chopin, Bach, Beethoven, List, Rossini, Verdi, Stravinsky, and Shostakovich. My mother Ada, had an exceptionally high I.Q., skipping a term in High School and graduating with honors. In those days, "a women's place was in the home". Never allowed the luxury of applying to college, frustrated she found solace in books and employment as a librarian. Bright enough to teach herself piano and possessing a tremendous "ear", she sat by the side of our Zenith consol radio, writing down popular melodies in shorthand. Later as her self taught reading abilities developed, she taught beginning piano students, and played commercially. Lois, my younger sister, four years my junior, was Mom's pride and joy. Born with a feisty nature that feared no man, she possessed an I.Q. similar to my mothers, in the 160 range. A fearless, direct, and no nonsense personality, pity the man who was condescending to her. So precocious, by the age of twelve with only two years lessons, she performed Chopin and Rachmaninov works at concert level. "No women's place in the home for her"—she was college material. High strung with a take-no-prisoner attitude, Lois was the complete package. Together they epitomized the forerunner of modern womanhood.

In our home art wasn't for the ego, but for the soul! Never distant, were my extended family brought memories of weekly visits to my grandparent's home. There

every experience was a lesson in applied culture. Great operatic themes floated through the rooms. If anyone could cajole my grandfather into dancing, it wasn't a folk dance, it was a dance of royalty; the pavanne or allamond. Six feet tall, slender, with steel blue eyes—I was mesmerized. Several aunts also blessed with perfect pitch, would harmonize and perform all of the "Andrew Sisters" songs. Next up were Sinatra and Louie Armstrong tunes. Rounding out the performance were the "Mills Brothers" and "Inkspots". The bass speaking parts presented a problem so Joseph (Junior), their fair haired, green-eyed "baby" brother filled in. Joseph was another six footer who was the dead image of Errol Flynn. Except Errol went to the movies, and Joey, as a paratrooper ended up in the "Battle of the Bulge".

Never to be outdone and usually ensconced in the corner of the living room, the male side had their own thing going. Dixieland, Blues, and Big Band music. Alvin played trumpet akin to Bobby Hacket and "Wild" Bill Davis. Doubling also on drums and vocals. Willy (William) trombone and tuba, Joey (Joseph Jr.) and Doris (D'ora), she was a blond, played guitar and sang vocals. Hugo the man of letters, intellectual like my mother, played clarinet and ragtime piano. Ada, my mother, the best pianist crossed over from group to group as needed. I won't explore the food and beverages, presented as a "help yourself" buffet.

Surrounding this rich mix and guarding the entrance to the living room, was a full size statue of "Venus de Milo" and various other statuary, to dim for my mind to recollect. The walls were adorned with: Rossetti, Delacroix, and Parish reproductions—definitely a Romantic slant. Now I realize what a wonderful inhaled cultural education was received! My fore bearers had gifted me with a passion for the arts by osmosis.

Rejoining that moment in the present, I would return to the collecting "days of yesteryear". It was good to be king again—at least a baron.

If I possessed one large advantage, it sure wasn't finances. O.K., you may rule out good looks also! My plus translated into this personal creed: *The Educated are Strong.

Added to this was a "wee bit" of family philosophy, passed on from a couple of brilliant uncles. The first rose to be president of national unions and an articulate

CHAPTER I

author. Progressing on to host high positions with the United Nations.

Revelation

> "Nothing is too good for those who are willing to work for it."
>
> -Ernest DeMaio

The second uncle, a man of the arts: a poet, author, educator, Military Officer (WWII), raconteur of humor, and pretty good musician (hey, nobodies perfect)!

Revelation

> Don't be a ne'er do well, do well!
>
> -Hugo (de Sarreaux) De Sarro

These lessons were neatly applied, with the greatest lessons of all received from my mother Ada, a brilliant woman. The love of knowledge and the importance of books! As some are born to "the cloth", it would seem I was predestined to the arts.

Structure and Content

Stylistically, I want to emphasize three very important presentation points.
"Revelations", the word revelation is used with the intended meaning of truth, revealing in nature, or learning process.

Quotes and Colloquialism are freely borrowed and purposely inserted. The intended reason is to create a simplicity of understanding and to simplify.

Underlining and ($) dollar symbol. Important concepts are stressed and underlined. The dollar symbol is used to attract your attention to money making advice and ideas.Example: "Let the games begin!" Roman games. Not a family member, come to think of it, possibly a distant cousin.

CHAPTER II
TO BE OR NOT TO BE A GREAT COLLECTOR AND WHO'S COLLECTING ?

Here for the sake of sanity and manuscript limitations, we will confine our endeavors to the collecting of fine art, and why most people fail! Gems, coins, and classic ears are another effort. So many potential art collectors are scared asunder, by the words "fine art", along with implied implications of huge expenses, or where to begin! I've often believed that a major hindrance and source of anxiety are those continuums of magazines, which always seem to discover! The "Next Great 101 Collectors" subconsciously leaving you with the suggested reaction, you've just missed "the last train from Shanghi (or) Hanoi". So why not analyze these collectors and delve into their selections.

Before we advanced a serious thought always do, "due diligence". Nothing beats education and research. Either "self-inflected" or the professional assistance of museums, community colleges, and night schools. These are all excellent sources of inexpensive information. (Sorry it's hard for me to leave the classroom behind.) <u>Returning to our primary mission, first evaluate the competition!</u> Then effectively guide your efforts in what to purchase and where to search for it. Here is an overview of the competition.

Group I Caviar & Champagne or Is It Beer and Pretzels?

Hypothetically speaking, and presenting those "101 Great Collectors". Let's peruse, dissect and separate these individuals into "sub-sets".

Group I

Probably the foremost reason the average person shies away from collecting appears to be half of those "great collectors" showcased, are self announced, or self proclaimed millionaires. It would seem, by the "Grace of God", <u>as soon as you have attained financial success in one field, God has anointed your artistic genius in fine art.</u> Your status achieves instant elevation and you are proclaimed "a great collector". <u>WHO THE HELL ARE YOU KIDDING?</u> Conveniently, overlooked is the fact that most of these <u>"legends in their own minds"</u>, employ private dealers, galleries, or agents to search and secure their fine art purchases. Of course in some cases there are honest time constraints. More so it boils down to just ignorance.

<u>When agents or galleries are employed, this positions millionaires as employers and not true collectors!</u> Giving credulence to the old saying "Ignorance is bliss". I understood this from first hand knowledge often witnessing petty fights over color association of furniture, site presentation, or who was the more self-proclaimed important person, buyer or seller! <u>Their presentation of self-aggrandizement prevailed over any true love of fine art. Look at me, I'm buying this art!</u> They should have been looking at the inherit greatness of the art. Remember my inference to "power and prestige"? Here it translates into self-centered arrogance!

CHAPTER II

Revelation

> The "noveau riche" often fail to differentiate any distinction between real culture, and the development of good taste! Their belief is that art acquired was the assumption of class acquired. "CULTURE BY ASSOCIATION"! In simple language, "A fish wife with a large diamond hanging around her neck, is nothing more than a diamond hanging on to a fish wife's neck—NOTHING HAS CHANGED!"
>
> -L.D.M.

A Perfect Example

I recently attended an "exalted" exhibit of an "important family's" great art collection. Yes, they paraded the required Picasso and Chagall works, which were far from prime examples. However, what was really missing was depth! Their collection amounted to a shallow display of wealth to "wow" the untrained eye. Missing were various mediums. Drawings, watercolors, work studies, or variations of style by contemporary artists. In other words—the "supporting cast".

You see smaller examples were beneath their dignity to acquire. Their shallow knowledge was parallel by the fact that they were "name collectors"—and not, "art for arts sake" collectors. Hypothetically, why pass on a magnificent water color, when you could boast: "I paid millions for this oil!" The sad thing was, recognizing the galleries they employed, they did to! If there was a true love of art, they could of spent half as much money, and acquired twice the amount of art!

Yes, their culture was purchased by association with "great masters" because their assumption was that art acquired, was also the acquisition of good taste. From a personal viewpoint, what was really paraded was a display of shallow arrogance and the lack of real culture.

THE ARTFUL DODGER

Revelation

"What price glory?"

I have been acquainted with and dealt with various members of noble families. Here on record, I (100%) support Democracy and not Feudalism. As a group the nobles weren't always the most financially complete set of individuals. Surprisingly, a majority did advocate a common knowledge and real affection for fine art. Trying to understand and analyzing this phenomenon, the commonality revealed itself this way. A great deal of their education was directed toward the humanities and arts. Their "culturalization" was acquired though a lifestyle first and not finances fist!

I remembered this wonderful Palm Beach gentleman of limited means. His Spanish ancestors were early landed settlers of New Orleans. Unfortunately, a younger brother wiled away the family's fortune. He possessed an extensive knowledge of art and clientele. Which he presented with a natural bearing—devoid of arrogance. Framed with a dry humorous disposition his presence was a plus for mankind. I noted, while others of immensurable wealth, fought to be accepted on the "A List", his social calendar was always filled with receptions and dinners.

Revelation

Education is the great equalizer, only then does the application of finances give you an edge.

-L.D.M.

CHAPTER II

Returning to the "Great 100". Very few of those "noveau riche", personally collected those important works of art. Guaranteed they did not go out on "search and destroy missions", but were presented fine art based upon other people's expertise and efforts. <u>So for these individuals their selection of art amounted to "pick and chose" and later "show and tell"</u>! (For those who have kids, you know what I mean.) Not sure who these great collectors are? Just pick up one of those slick, tacky, glitzy magazines. I have more respect for those people I've met at "tag sales". We will revisit this crowd later.

<u>Group IIBelieve it or Not? "Exotica"</u>

Usually sub-group two, collects with honesty if not always intelligence. <u>Their collections are odd or exotic.</u> In Connecticut there is a "nut museum". Need I say more? Please don't send me invitations to opening night exhibits. Of course this is an impressive collection. <u>How many "nut cases", excuse the "Freudian slip", nut collectors do you know?</u>

Now on a slightly more elevated level a few words regarding "exotica". Because we are human, I understand that certain collectors may be emotionally attracted to unusual "objects or left relics" from historical collections, or family heirlooms. Remember exotica is exotica. Sometimes referred to as "<u>collectibles</u>". Be they Civil War Buttons, or walking canes. It is a <u>very thin market</u> and therein lies the inherit weakness. Skeptical, canvas your neighborhood and inquire: "Any Spare Civil War Buttons"? Town-wide? O.K. on the state level, a few kindred souls? <u>Forget what you saw on the "tellie", because they are addressing a mass market!</u> With a very narrow field of interests, time and time again, the dealers recites the following:

"In my lifetime I've only seen two of these hand-made, yarned darned, cow utter, milking gloves". –Durr--?

Yes he places an extreme value on the item. Your rich beyond reality, until you try to sell it! If you think the gloves are scarce, wait until you try and find the collectors! I have a friend who will collect anything having to do with Rhinoceros. Yes, you heard

me right, forget buying a new hearing aid. Recently he spent a small fortune purchasing an "Important Rhino Horn, (as told) once owned by a famous comedian". I believe without any written documents to add to the greatest rhino collection in the world! Of course, it may have a practical side. I've been pushing the idea of boiling that horn into the "Zuppa di Giorno". I really want to test that aphrodisiac theory. I confess some time ago, I did sell this person an authenticated, signed original, rhino drawing by Salvador Dali. Now all things being equal and you were offered the choice to buy one of these two objects d'art, which would you prefer? See, that's why they call it fine art. Most people are content with seeing a live rhino in a zoo!

Revelation

Here is an important lesson to observe. Audience size and participation have to do with the "store of value" humanity assigns to objects.

-L.D.M.

Crystallizing this premise, could this be the underlying reason why we have thousands of museums that deal in fine art, and only one "NUT MUSEUM"? Do you really want to endow a museum for nuts? – Enough said!

Group III"Antiques", on the road show?

Now we present a smaller group of individuals who were left a collection, object or received family heirlooms. Sorry, we won't peruse these individuals, because these people are really "curators and not collectors". They received this good fortune, and

CHAPTER II

"God Bless them", if they were smart enough to take care of their family's treasures. Of course you may observe them, on the wonderful public T.V., "Antique Road Show", where they are often displayed. No wonder, it's because their knowledge of their possessions are nil—<u>clueless</u>! As a sidebar, periodically it is brought to my attention, the re-discovery of a semi famous painting hanging on the wall of some small local town hall. Again, it is usually community property—never really loss— probably miss-inventoried or misplaced.

<u>Revelation</u>

Curators care for, and collectors find!

-L.D.M.

Usually making up the remaining quarter, are the true collectors. You may identify them because they really have attained impressive art collections, for finances allotted. Their single largest expenditure was time first, and capital second. From an evaluated viewpoint, their successes were achieved for a third to two-thirds less than more well heeled contemporaries. Serious collectors also impart a passionate knowledge of their subject matter. On occasion they are even willing to dispense with their "first born sons". (I'm taking bids on mine.) Compare this to the sad and often told tale of "big V.P. collectors". When their corporate level use car pitches and stock options bottom out, the first thing appearing on the auction block is fine art. Auctioned are old masters and impressionists. No sentimentality here. <u>They "purchased" this culture and now its time to sell it.</u>

Revelation

Conclusion. Don't worry about the competition, it's really very thin! Remember there is always time to be a true collector! Several words of advise bare repeating: "No rule of success will work if you won't, and, it's a big ocean, so learn to swim"!

-L.D.M.

CHAPTER III

The Problems of Collecting
How to Become a (Serious)
Professional Private Eye

<u>You have to be realistic and make decisions</u>, right from the start. Use common sense! Unless you're lucky enough to find an "old master" in a garage sale, then don't pursue this venue and "beat a dead horse". (By the way, we are going to deal with making the right decisions more in depth later.) <u>Ask yourself this question:</u> When was the last time you, or anyone you know, truly found the "Holy Grail"? Well, if your still hell bent on an "<u>old masters</u>" collection, then confine yourself to less expensive prints and drawings, (which tend to be more readily available)—basically, <u>works on paper</u>. ($)These will occasionally surface and then you will have to deal with the <u>real problem of authenticity</u> – not to mention <u>condition</u>.

<u>Authenticity</u>

Let me site one small personal example:

Giovanni Battista Piranesi was a 16th century Italian artist and engraver. However, his original endeavors were directed toward becoming an architect.

During the summer solstice, Piranesi would travel to Rome. His mission was to study and sketch the ancient ruins of "Rome's Eternals" magnificent temples, and government buildings. Becoming emotionally conflicted with these deplorable

condition and classic grandeur, he decided to raise funds for restoration. When his efforts failed, he blamed local politicians and the "Nuevo rich", which had opted to move to the "burbs". Years later he extracted a measure of embarrassment, by including in his now famous etchings, farmers, beggars, and the poor among those magnificent ruins. Those classic etchings soon provided him with a measure of fame and a comfortable living.

I retell this tale because many dealers still bring his etchings to market. Some individual dealers are aware of their worth, others don't care. Now the question arises, what are you really buying?

<u>Example:</u> I was offered a real Piranesi etching, over three hundred years old—hardly! Even with my limited knowledge in this area, this much I know!

<u>Remember Piranesi was Italian, and at the bottom of each etching he included a written description, either in Latin or Italian.</u> Also, he often stamped a Roman numeral on the etching. Examining this etching, <u>I noticed the script was etched in French and not Italian.</u> I knew from past research that when Piranesi died, his son sold the plates to French engravers. Sans Latin and hello Françoise! French engravers commenced to print Piranesi etchings, by the thousands. I realized inspecting this etching that the original script was gone and replaced with French and I couldn't locate any numerals. <u>"Flashback", the "old coot" liked to label and count!</u>

<u>Conclusion:</u> these were not the original edition etchings, and neither were they rare or three hundred years old! "The fact of the matter" was, so many American public classrooms prior to 1950 displayed them, they were really a "dime a dozen", and often worthless.

Revelation

Seeing isn't always believing, so always ask for the history—provenance.

CHAPTER III

Condition

Besides authenticity, condition is of the utmost importance. Here we may only "scratch the surface", because this exercise has to do with discovering art and not art conservation.

Major Concerns for Works on Paper

1.	Rips & Tears	Self explanatory—check edges and corners.
2.	Creases	Again self explanatory—common on large posters.
3.	Flaking	Common to pastels—loss of pigment. Here you need a spray fixative. Check with your local art store for various products.
4.	Discoloration	Very serious! This usually is the result of chemicals leaking into the print. This often results in a tan stain color normally found under mats. Until a decade ago, "professional framers" had to be told to place acid free mats and mat boards on fine art. Currently it is now the practice to ask you for conservation backing (still a good thing) because they want you to believe it so expensive but needed. Half truth—yes, and needed—yes. The wholesale cost to the dealer is around $10.00 a sheet extra, so negotiate!
5.	Foxing	Little brown spots—"dot like" spots that a product of moisture! More commonly known as mildew. In the seventeenth century this was thought to be caused by witches. We now favor the theory that it's because of bad relatives, on your mother's side of the family.
6.	Trimmed Sheets	In this area never opt for "a little off the top". Cutting a work on paper to fit the frame—you will lose value, and this is a definite no, no!
7.	Framing	Remember, for the most part, "frames protect, but

seldom appreciate". Excluding hand carved Renaissance, or Early American frames.

8. Selecting a Frame My rule of thumb is match the picture and period, to the frame. If you decide to match it to a piece of furniture, that piece may be gone in five years.

Revelation

Those conditions noted, can be repaired by a professional conservator. Use common sense. Moisture and sunlight are two "killers"—be preventative. If you repair after the fact, it will be more expensive. Need help—call the local museums, or "walk" the yellow pages.

Oils and Acrylics

In general there are more items to check when dealing with oil and acrylic paintings, other than those reviewed, relating to "works on paper". Actually, many problems with works on paper are innate to the original materials. Oils and acrylics present additional issues. The following is a partial disclosure list:

1. Paint-overs One image laid over another. Here it takes an x-ray machine for disclosure.

2. Touch-ups or "in- Basically any new paint added to the original surface.
 painting" If it wasn't there to begin with, it's not original. Of course, you have to "temper" this with reality, because many older paintings have been restored. Others

cleaned up for appearances sake. Touching and in-painting seldom accounts for more than 20% of the surface. <u>Great masterpieces are never corrected—cleaned, yes!</u> Are you volunteering to paint over, or touch up Mona Lisa's smile? The suggestion here is to take out a life insurance policy first.

<u>Revelation</u>

Available at art supply houses are portable <u>"black light flashlights"</u>. When the ultra violet light beam saturates the surface, any newly painted work will turn white, or lighter in color. Here we have a real <u>physical revelation</u>!

3. <u>Copies and Paint-overs</u>

Many 18th and 19th century artists were so impoverished; the means to acquire materials became a problem. Picasso, early on his career, painted on anything that presented a flat surface. Board, cardboard, poster paper, etc. The normalcy of painting over, one image on top of another, was a common practice. <u>Of course, forgers use this technique to infer there is a great painting lurking below the surface.</u> Major museums will have art works x-rayed to pry beneath the surface. X-rays will register older lead and minerals used as coloring agents. <u>If your masterpiece is relatively new world, and not worth a cool million, then examine the canvas where it bends over the wood frame. Look to see if there is</u>

more than one layer of paint. This in itself is not condemning, unless you're supposed to be viewing the original image. With digital painting techniques, modern technology can paint canvases with such accuracy, that certain countries and legitimate dealers stamp the word "copy" on the reverse. You may be presented with an old world masterpiece, check to see if the edges are perfectly straight. This may be an indicator that your looking at a digital copy. How many drinks do you need to steady your hand? A machine doesn't!

4. Pigments, Chemistry and Chemicals

Forget that old saying that starts with "If it looks like a duck", because today it could be made out of soybeans! Think about it! You may enjoy a strawberry shake, both the taste and aroma will deceive your senses into accepting it as authentic. Surprise, the words "real strawberries" never appears under listed ingredients. Centuries ago artists ground berries, roots, various organic matter to achieve a range of colors. Every artist had his various formulas, or sources available, kept private and guarded. These and the period of use, would allow art detectives to track back in time their origin. Contemporary make up of formulas and dyes has changed, including various methods of application. Delivery methods are not limited to oils and acrylics. Even watercolors may be analyzed retrospectively to place of origin. When the formula is decoded, then the date and place source of origin is assigned.

You don't care who says what, because you know your art is a real masterpiece! Well, I advise you to

search for laboratories that use carbon dating testing. Impartially, this will establish the age. However, it will not prove the authenticity of the originating artist.

5.	Acrylics	An oil derivative water based paint. These became popular and began appealing in force after 1950* Soon dethroning oils, as a medium of choice. Artists love acrylic because they are fast drying, almost odorless as compared to oils, looks like oils, and may be thinned to the consistency of water colors.
6.	Oils	The opposite of acrylics. Oil based paints are slower drying, more odors, and the ingredients are often more toxic and in some cases dangerous to the artist.
7.	Giclee Painting	Minute dot sprayed inkjet painting (akin to pixels on digital cameras). Relatively modern printing technique. This method gain followers among printers after 1980*, and made it easier to print limited editions on canvas.

* Note: Dates assigned for painting techniques are in general—"circa".

Antiquity, Aging and Fraudulent Techniques ("Made in Havana")

1.	Aged or Stained Paper	Coffee, or "tea for two". Both of these household staples are wonderful for creating the appearance of age, (loaded with acid). "Good to the last drop"—so apply as needed.
2.	Aged, Cracked, Old Painting	Don't throw away that old hair dryer—you may need it for touch-ups. Need a more even approach? How about low temp baking in the oven—great for yellowing (basing)—even Ms. Stewart would be proud of you.

3.	Smoke Dreams	Cigars, now we are talking my personal favorite. Just leave your painting in a smoke-filled area. The nicotine tars make a great aging adhesive. My selection to accomplish the task would be "Connecticut Broadleaf" (dark), Havanas, or Maduras. "Smell that Monet, what a great vintage". I wonder if it is covered by Medicare "B", or aged in Havana?

Signed or Unsigned

1.	Signature Books	Published by art houses are available to collectors. They illustrate and display thousands of examples of artist's monograms. These are similar to "mark" books for china and silverware. If these are too expensive for personal (limited) use, try your local library. Note, signatures will change from period to period. Match the style with paintings date, if possible. Salvador Dali's signature changed throughout his lifetime. There are some "tell tale" elements to analyze. Look for constant factors: pressure, slant, spacing, loops, flow and speed. How are the "I's" and "T's" dotted and crossed? Hey it worked for "John Hancock".
2.	Non-signature	If a work of art is unsigned, that doesn't mean the work is "Persona non grata". Authentication may prove more difficult, however, there are legitimate reasons for unsigned works. Many artists only signed completed works. Washes, which are quick water color sketches are another area. Important artists such as Georgia O'Keeffe, often "skipped" signing major

works. She may have felt her work was so recognizable that a signature wasn't required.

3. <u>Plate Signed</u> Here the work on paper is a signature etched on the original plate or stone. The downside is these (like dollar bills) they may be mass printed. On the serendipitous side of this issue, that leaves a treasure trove of originals out there!—Explore!

4. <u>Twice Signed Pieces</u> Contrast this to Dali, he was a signing machine. Many of Dali's pieces were both plate and hand signed—twice signed. His most ambitious work on paper, also considered his most important and desired work was the <u>"Divine Comedy"</u>. Dante's setting of Heaven, Purgatory, and Hell (in 1951) commissioned by the Vatican was hand and plate signed. Only <u>the first</u> 150, plus "EA" sets, woodblock printed, were hand signed, in three colors. <u>Red pencil represented "Hell", purple for "Purgatory" (for Catholics it relates to a "holding cell"), and the blue signature equates to Heaven.</u> A second edition was signed in regular pencil. These also became twice signed. Later, French publishers together with Dali's agent printed thousands of sheets in portfolio and book form. These earned only the plate signed stamp, and are of minimal value, lacking the brilliances of the original edition of 150 and "EA" sets. <u>A note to Dali collectors of the "Divine Comedy".</u> Approximately a year after the original edition of 150 sets, etc. were printed, the so called <u>"Deluxe Sets"</u>, made there appearance. These were basically unsold original sets, with either one original W.C. from the Divine Comedy added. Others were "pitched" with the Dali lithograph—"the three

muses". I guess sales were slow!

Allegedly, De Kooning realized, cost-wise, even his signed and numbered editions, were exceeding the reach of the private collectors. So publishers were required to print, in the same run, an equal number of plate signed sheets. Prior to there release, these were pencil number either by the publisher or De Kooning. <u>Example:</u> "<u>Big Blond</u>" (150S/No.) and 150 plate signed with hand numbered. (This is an abstract image of Marilyn Monroe). Of course, this plate signed edition is still a far lesser value than the hand signed sheets, however, in this case they do have the added creditability of number control.

* EA – French for Artist Ecole. Americans refer to these as artist's proofs (A.P.)

<u>"Devil on the Keyboard",</u>

<u>the first colored limited edition lithograph, by De Kooning was entitled, "Devil on the Keyboard". Printed were two sets of seventy-five (150 S/N) pieces.</u> The second set has the words "Rainbow Devil" added. These also should have a like number of plate signed sheets. We will revisit the "Devil" later!

5. <u>Exception</u>

Dega felt that his lithographic editions were of minor importance, so at the time of his death those found in his studio were stamped. There is an official set of stamps on record, along with their impressions. The issue here is these prints today are rare and very valuable works on paper. A note of warning, forgers realized the valued of Degas lithographic and have gone to great lengths to recreate even the stamps, for fake editions—be careful!

6.	<u>Gifted or Unsigned Pieces</u>	Of course the perfect solution is to request the artist to sign and dedicate the artwork to you. Possibly you may ask the artist to pose in a snapshot with you and the gifted piece. Tell him it is for your records and the family album. Wouldn't it be nice to have a picture of you and Matisse on your mantel?

<u>Schools, Styles, Labels</u>
<u>However No Guarantees</u>

Let me relate a recent experience. At the time of this publication, I purchased from an art dealer a good size drawing with the initials "N.R." near the bottom of the page. <u>This dealer thought it might be "Norman Rockwell" and listed it as "attributed".</u> I took one look and silently agreed. From a technical viewpoint it looked solid to me, and immediately I began researching this piece. Having an idea where to look, it uncovered the major painting, which inspired this work. I believed his drawing to be the final work study for the painting. Knowing that this particular artist signed the majority of his efforts, large and small with a full signature raised a red flag. This work was signed in the initial, plus there were other minor areas of concern. A few of the features were different and the final painting was larger. I kept returning to stylistic points of detail and shading. Checking monogram books, for like examples of signature initials. I looked so hard at this piece that my wife hinted I was perverted. Now came the hard part. No, not dealing with my wife's "low-life viewpoint", but shelling out several hundred dollars for authentication—with no guarantee of authenticity.

I phoned the Norman Rockwell Museum and asked for the curator. A delightful and helpful voice explained that the museum wouldn't authenticate works for legal reasons, however, there were experts the museum relied upon for approvals of presented (found) works. Well, I drove to the museum's expert, with the understanding I had to pay with no guarantee. It was starting to sound like a broken record. I made my presentation from the research facts garnered and passed over the

drawing for inspection. Never under-estimate any particle of information collected, when researching a work of art. Previously, I mentioned I had traced this drawing from upper New York state, to the California dealer, which was the source of my purchase. He blinked while still pursuing references, back and forth, while studying the sheet. Suddenly proclaiming it was authentic! Not only authentic, but long lost. Continuing, he informed me that he would work up a folder for my personal records and notify the Rockwell Museum, requesting them to list this work in the museum's catalog of authenticated works. With the recorded ownership under my name. Also relating to me that Norman Rockwell, was in fact living in nearby New York state, probably at the time of this work's origination. Soon after moving to Stockbridge Massachusetts, where his friends and neighbors became models for his famous paintings. For what it's worth, I feel "Norman Rockwell" will be remembered as the greatest visual communicator of the American seen in the twentieth century—HINT!

The total cost of my original Rockwell drawing including authentication, was around $900 dollars (the appraised value about $9,000 dollars). The welcome silence from my wife—priceless!

Don't you just love the word "Attribute"? Indeed this was the final "work study" for a famous Saturday Evening Post cover entitled: "Fleeing Hobo", appearing on the August 18, 1928 cover.

Additional Labels

Other labels commonly used implying authenticity not as strong are:

1. In the School of: A group of artists with similar styles, often relating to a group or period.

2. In the Style of: Similar to other known artists with the implications of certain technique.

3. School of, With Country Added: A very general (reference as to location) or traits. Example, French school.

CHAPTER III

Consumer Alert! If you are approached with a work of fine art from "the School of Hackensack" (New Jersey), please take this with a grain of salt!

Exceptions. Of course there are exceptions and some are important, as in this case. "Art Deco and Modernism"; these labels are universal in nature, so we will pause for a short overview!

Art Deco and Modernism

Stylistically, now it is popular to unite these two periods together. Art Deco and Modernism span the period from about 1925 to the late fifties. The early decades are usually referred to as "Art Deco" and the later decades are promoted as "Modernism". Without any clear line of delineation, I have selected the year 1935 for Modernism. This period is best recognized by the descriptive adjectives and characteristics applied such as: streamlining, clean lines, lack of heavy decoration. Implied use of Greco-Roman and Andrea Palladio, inspired architecture. These characteristics universally were applied to everything. In the field of fine art, shortly after the turn of the century, the word "modernism" was used to describe progressive efforts of American artists from Cubism to color and design variations.

Soon automobiles, planes, trains, steamships, even furniture, fashion, jewelry, glass-wear, and even coffee pots were "modernized". Icart and Erte epitomized artistic high fashion, while Cassandre and Paul Colin gave new life to posters. Famous fashion houses involved themselves with this great artistic movement, carrying on their own war. "Coco Channel" favored clean crisp lines, her competition "Elsa Schiaparelli used bold colors and matching outfits. Both befriended musicians and artists sponsoring and including them in their inner circles.

These activities were carried out against an explosion of architecture. From the

vertical development of "skyscraper growth" in Chicago and New York City, to the "South Beach" Art Deco area of Miami Beach. Outside of the United States, the pioneering efforts of <u>Rennie Mackintosh</u>, from Glasgow Scotland, in the field of art, architecture, and interior design were often overlooked, or seldom given deserved credit. Frank Lloyd Wright, masterful residential design "falling water" in Bear Run Pennsylvania, set the hallmark, uniting modern clean lined architecture and nature. Built in 1936-1939.

Aside from Rockefeller Center and Radio City Music Hall, my personal favorite concert halls are the Bushnell Memorial in Hartford Connecticut. Possessing breath taking interior beauty, also displaying the largest Art Deco Mural in the world, painted on the ceiling. An honorable mention might be assigned to the recently created "Kravis Center" in West Palm Beach. The lobbies are sweeping and magnificently designed, however the concert hall is of relatively smaller proportions. You receive the impression that to go there is to be seen, and not see the show! Again, what price glory, you decide?

<u>AUTHENTICATION AND CONDITION</u>, WELL WE HAVE JUST SCRATCHED THE SURFACE, BECAUSE WITH EACH INDIVIDUAL ART WORK, THERE ARE ALWAYS NEW CHALLENGES AND CIRCUMSTANCES.

<u>Revelation</u>

There are many smaller works listed as "attributed" by Galleries, or lazy non interested owners. They are either disinterested or won't invest the time to establish provenance. Many of these pieces "stand up" on all accounts of style and signature, etc. <u>THIS IS AN EXCELLENT AREA OF DISCOVERY—GET BUSY!</u>

CHAPTER IV
FIELD OF DREAMS?
HELL, FOCUS ON FIRST BASE!
(SCHOOLS, STYLES, PERIODS AND MOVEMENTS)

Once the decision was made to indulge myself with collecting fine art, my plan of action was to limit my efforts to "20th century" fine art. My reasoning was how much art could possibly be created, in just a period of one hundred years? We pause for a moment.

At this time, may I nominate myself for "Best Character Actor", in the "fools" category! I believed I had really narrowed the field down. Boy was I wrong! Just a hundred years. IT WAS THE BIGGEST MISTAKE I EVER MADE IN TERMS OF COLLECTING! Here is why:

The voyage of the past century (one hundred years) probably has encompassed the most creatively rich and culturally productive period, spanning any century in the past 2000 years! In terms of collecting, it's a candy store of schools and styles. Survey this list, and "check them out" at your leisure.

1. Impressionism – (Pointillism)* sub-school/style

2. Cubist – (Orphanism)

3. Fauvism

4. Futurist

5. Expressionists – (American Modernists)

6. Surrealists – (Regionalist, WPA/Latin Art)

7. Art Deco (Early) – (Art Deco Modernism)

8. Abstract – (American Realism)

9. Photography – (growth of mix media)

10. Pop Art – (Installations)

In retrospect, just review it as a glorious sunrise and sunset.

20th Century Art

The intent of this illustration is to diagram available choices to pursue. Also you should note that art schools and styles presented here do overlap and are furnished only as reference points.

Let's magnify one small "slice" of this wheel, limiting your field of concentration to the crossover school of Impressionism, at the turn of the century. <u>Look at the available variations and styles to collect:</u>

Impressionism
French – (original) Artists
Partial: Cezanne, Degas, Manet, Sisley, Pissarro, Renoir, Cassatt (American)

American Impressionists – United States
Connecticut Schools: Old Lyme and Cos Cob

Regional (East, United States)
Pennsylvania and Ohio State Impressionists (Philadelphia and New Hope School)

Regional (West United States)
California Impressionists.
World Wide Movement

CHAPTER IV

<u>Impressionism</u> influenced the entire world and to paraphrase Winston Churchill, at the close of the "Battle of Britain", "It could possible be <u>the end of the beginning, or the beginning of the end</u>". It certainly was the "wake up call" for modern art.

<u>Don't move!</u> There still are further decisions to make—your only half way home. Think about this.

Which artist or artists to collect?

1. Which school or styles of art (Ex. W.P.A.)
2. Which Mediums: Works on paper, pastel, oils
3. Representational: Examples of several styles
4. By Country: (Spain) Dali, Picasso, Miro, etc.

These are just a few ideas—"food for thought". When anyone asked me what I collected, I was quick to hide behind the wall of generality and say "just twentieth century art". Yet, my personal collection encompasses the entire twentieth century. Beyond Impressionists there are examples of fauvism to Surrealists—Abstract to pop artists. Throw into this mix: illustrators, regionalists, Latin artists, Art Deco, WPA, modernists, abstract, and pop artists. Oh, I forgot my classic black and white photography collection: Man Ray, Ansel Adams, Halston, Evergood, Lini Refenstahl and even a Mapplethorpe. Of course this is just a partial list.

Believe me, now I listen and even follow the doctor's advice and take an aspirin a day for my heart. <u>So take "heed" on you could end up like me. I became a passionate collecting machine, with a huge canvas to fill. Art was a feast to my eyes, and I love to eat.</u> I blame it on genetics; remember I started out as the "King of the Box Top offers".

Someone had to empty those boxes of cereals, or "Spider Man" never would have jumped off a building. "Batman", would of still been walking—no "Bat Car" and T.V. Tom Corbet, "Space Cadet", would have been grounded. It's also reasonable to believe I possible would have set the worlds running record (for a white man) escaping from my father! I firmly believe I performed a noble and important service for mankind by financially supporting those American legends! That childhood

experience of being the "King of Collectors" would do me in. <u>So you have been officially warned—FOCUS!</u>

There remained only one "flaming" question that needed to be answered. <u>"Where the hell was Betty Ford and her clinic when I needed her? I'm still a recovering collector!</u>

<u>Revelation</u>

Limit thyself to a school or style, even objects of art—examples, letters and art manuscripts. Museum and curators like simple concepts such as: Still life's, Figurative, Minimalism, etc. It makes it easier to do an entire exhibit on a theme.

CHAPTER V
Where and Where Not to Find Fine Art
"Or the games a'foot Watson"

Now pay attention, isn't this the main reason why you purchased this book so here's the "rule of thumb".

$ When possible, go to the source area, where the style originated. Your "gut" reaction is "easier said than done". It's not on your vacation agenda, your family is holding out for "Disney World", and not the "Louve"—Ingrates!

$ The solution is, bring the art world to you.

$ Subscribe to national art magazines, big city newspapers, (New York Times—section II) has ads, classifies and exhibit schedules.

$ Sign up with your local and regional auction houses, placing yourself on email and mailing lists.

$ Join museums and especially their service organizations. In doing so you will start to address those background areas, while developing a feeling of normalcy in that environment.

$ Don't forget eBay; they really have some exceptional bargains. Even if only partially successful the "medium is the message" (learning process), and it's free to participate. We will discuss "eBay" at length later.

THE ARTFUL DODGER

The Local Scene and Criteria for Looking

A frequently asked question by the unbelievers (Contras) is: <u>Don't most local galleries sell fine art? Look, even the sign in the window proclaims fine art? Answer: In general it is no!</u> More than a third are just frame shops and actually framing is their major source of income. <u>Next couple to this assembly, the largest segment of local galleries, selling what is known in the trade as:</u> "GREETING CARD ART". O.K., never heard of that term before? You're confused? In need of an explanation? Want some guidance?

This specie of "Art Monger", prays upon the weak and unsuspecting. <u>Group wise they may be identified by the artistic inventory presented for sale.</u> When you realize how to recognize the enemy, they are self-revealing. Presented is a partial list of images to anticipate:

A. The cottage with lights a glowing
B. The mill by the stream
C. Poppies in the field (poor Monet)
D. Defenseless puppies, ducklings, kittens, lambs, etc.
E. Sun bonnet brimmed forlorn lover by the garden gate—usually looking out to sea

<u>You got the idea, real "tear jerkers" material.</u> Sob—Sob—Sob! The "Coup de gra" <u>is a presentation normally served up in Impressionistic style, surrounded by a very expensive "frame up!</u> How's that for "rubbing salt in the wounds"? That dealer just paid off the second mortgage on the old homestead.

Of course there also are many excellent local galleries; sorry to say they are in the "wee minority". Here is how to identify them; look for the following characteristics:

1. <u>Exhibits present the artist first, then the gallery</u>, with framing only a by-word.
2. <u>Feature artists' resume</u>, normally includes a college major in art (not a given but a good indicator). Studies with other important artists and museums, or

other strong gallery <u>credits</u>.

3. <u>Physically, the gallery walls</u> aren't adorned with framing samples to the detriment of the art.

4. <u>Presented are semi-established or established</u> artists, together with originals and limited graphics, with provenance.

<u>Revelation</u>

<u>Beware; if the artistic thrust is directed toward nostalgia and framing, rather than creativity and draftsmanship, my guess it's greeting card art.</u> If this is the case, you're better off running to your nearest card store. At least there you may always buy "the very best"!

<u>Decorator Art "Splash and Dash"</u>

Here is another complicated arena, plenty of mine fields here! <u>Decorator art relies on "over the top", excessive colors, techniques and stylization!</u> Harder to define than "Greeting Card Art" because it is usually more <u>contemporary</u> and to the moment! <u>Favorite areas displayed are: Pop art, fashion art and abstract art.</u> Publishers and manufactures of this genre (artistic creation) freely borrow ideas from established artists and their styles. <u>It may look like a "Gucci" handbag, but why does it smell like fried rice from China?</u>

Routinely, clever publishers lift printing techniques, to <u>blur</u> the line between fine art and decorator art. <u>They purposely "defuse" by association, to imply value in excess of reality!</u>

"See here, it's a signed limited edition—artist signed".

Think about it, it could be anyone's signature, including the head of the maintenance department. Gift wrapped with a few stolen stylistic elements and it's "cash cow" trail for the dealer.

If you're suspicious your about to be confronted with this type of dealer, here is a good "virus anti defense". <u>Simply ask: Did the artist originate this artistic style— create it?</u> Don't accept the generic answer, "of course he created it". "No, I mean did he <u>originate</u> the style and not just this work? The emphasis is on the word <u>originate</u>!

<u>Wake up!</u> Up to now I've done all of the work and allowed you to grow lazy. Now it's your turn! So—I'm putting you to work (minimum wages of course),—sound familiar? When it comes to the original artists and techniques, vs. decorator stylization, your investigational efforts will lead to disclosure and discovery of what's the "real thing". In other words: "Where's the beef"?

Here is Your Assignment

<u>Look up the following list of "pop artists" and list three elements of their style such as: favorite themes or subject matter, color, mediums, techniques, size, prospective, design, procedure, application, etc.</u> You will begin to realize how <u>unique</u> each artist is, while still belonging to the <u>"same food group"</u>!

Here is a work chart to guide you; another example of your "tax dollars at work".

CHAPTER V

"Pop Art" Artists(partial list; same school)

Artist	Element I	Element II	Element III
Andy Warhol			
Keith Haring			
William Coply			
"Crash"			
"Christo"			
Jim Dine			
Rosenquist			
Larry Rivers			
Basquiat			
Mel Ramas			
Kenny Schraf			
"Red" Grooms			
Robert Indiana			

THE ARTFUL DODGER

Artist	Element I	Element II	Element III
Peter Max			
M. Kostabi			
Keith Koons			
Chuck Close			
Tom Wesselman (UK/US)			
Damien Hirst (UK)			
Richard Hamleton (UK)			
Edward Paulozzi (UK)			
Robert Blake (UK)			
Allen Jones (UK)			
Mimmo Rotella (I)			
Patrick Caulfield (UK)			

Artist	Element I	Element II	Element III
Others			
Others			

* Please note these are not presented in chronological order and many of the listed artists work in several fields (cross-over) during their lifetime.

Once you develop a feel for individual artistic styles, this will allow you to navigate your way through those dangerous minefields.

Revelation

Remember, good decorator art succeeds by "capturing" the essence and style of a previously original school. The promise here is, don't over pay for a "second hand rose".

The third group presented for discussion isn't as large as the previous two; however they do <u>present</u> a real "enigma" for the beginning collector. The dilemma here is even the most establish artists, such as Dali and Warhol have resorted to this technique allegedly. The current allegedly "king of the road" is "Jeff Koons"—building an entire career on this method. Did I forget to mention Cindy Sherman?

THE ARTFUL DODGER

Self Promoted and Self Published "Beware, there's a Muddy Road Ahead"

A noticeable trend surfacing in the past twenty five years, has seen galleries and individual artists publishing themselves. This is akin to self published ,self included authors. Part of the problem originates with the reality that there are fewer outlets for the average artist, as opposed to new authors, and their exposure possibilities.

Unlike bookstores that present a multitude of new titles and subjects, at any given time. Art galleries offer fewer opportunities and exhibits and therefore play to those themes that support their customer base. If a gallery is successful with "Regional or WPA" artists, such as Thomas Hart Benton, Grant Wood, or Paul Cadmus finding financial success in this area, they will exclude other artistic schools. Artists who practice "surrealism" or "minimalism" are "persona non gratis". Compound this with a second built in problem. Acknowledging that galleries usually feature a "book of the month" schedule, and there are only 12 months to a year, thus limiting the numerical exposure possibilities. Most galleries try to overcome this handicap presenting several group exhibits. Artists relate these limited exposure possibilities as, "so why wait, life is short, I'll blow my own horn!"

Self publish artists are both a good and bad situation for the collector—"a mixed bag". Good because the artist has a right to exposure and make a living, and bad because this can be an area of "jeopardy" for the collector.

Past generations of successful and accepted artists were established and published, because the art world recognized there unique contributions. Not so today! The situation more often is that the artist or gallery will self proclaim there own greatness. Over emphasizing their importance again far in excess of reality! These proclamations clearly avoid how marginal and non ground breaking they really are. Fashionably presented with some exalted philosophy or unheard of technique.

Just because you haven't experienced "Installational Art", "that doesn't mean your local museum staff hasn't been there and done that". The problem surfaces when many of these self proclaimed works are presented as "the second coming of the Messiah"! Have you noticed how many later day Impressionist painters are now reinventing themselves as "Plain Air Painters"? Wake up! Most of the original

CHAPTER V

Impressionists painted outdoors to begin with! How long can you "milk" the public?

The Next Great Unknown Artist? "Remember this Oxymoron"!

Most galleries promoted local artists and it is wonderful that they do so. When presented by describing there end uses as: fine colorist, wonderful draftsman, excellent portrait painter, or fine still life painter. With a list of credits! No problem! The trouble surfaces when galleries go beyond that level of presentation and become "Soothsayers". Hyping the originality level as being the greatest innovation since the discovery of "sliced white bread". Start running for the nearest exit. The "naked truth" is that they are selling to your vanity. Let me disclose this "come-on", in more familiar terms. "Don't you want to be the first kid on the block to own one?" Columbus already discovered America, yes Leaf Erickson too!

Want a dose of reality? First off the artist, publisher, and gallery are probably one in the same! There clients usually are "upward mobile" people who are just "ripe" to attain "cultural heaven" status with disposable cash. The other customers are wide eyed novices who identify with the gallery's subject matter, and proclaim, "This is great art". United by a like minded crowd that already are "financial legends in there own minds"! Why not seek out art that which is socially of their class and level? Naturally, the "curator" (manager) is quick to comment, "on their excellent choice and vision", reinforcing those preconceived beliefs". "Shazam", lightening strikes! Out comes that checkbook, often for many thousands of dollars. Remember that old scientific theorem? Water seeks its own level? True no laws were broken, an honest transaction completed, and a great artistic value consummated. Wait! (Two out of three isn't all bad.) "Run" that last one by me again. Great artistic value? "Remember, beauty is in the eye of the beholder", the curator proclaims. Isn't that a great disclaimer? "Eureka", finding this customer was that commercial art gallery's dream. "ONE JIVE TURKEY SERVED UP, SELF BASED!" Forget Thanksgiving, Christmas just came to this gallery first.

THE ARTFUL DODGER

Scenario (Not "Sex in the City", more like slaughter in the suburbs)

Van Dope, rushes home with his magnificent artistic discovery. Proudly hanging his great find for the world to see. As a decoration, not bad! Now remember Van laid out a lot of "moola"—huge bucks, so he might bask in the radiant glory of this monumental achievement. Something is missing? <u>Greatness needs an audience to be appreciated. "Let's have an opening"</u>! I'll invite the neighbors, job underlings (they'll have to come) and even poorer relatives, throw in some artists and museum volunteers for legitimacy. The plan is complete when his "illumination of achievement" is truly appreciated.

At the appointed time the invited entourage descends wide-eyed with their social acceptance. We have an invitation to the "big house", addressing some less fortunate employees. Under a faux crystal chandelier, a wonderful buffet was served. Slaved over by Van's brow-beaten wife, ostensibly decked out in a mink trimmed apron. Exclaiming, "Van always turns the air conditioner so high, I was frozen", explaining to the "dollar store" dames in waiting!

The moment of anticipation and great unveiling is at hand. The audience has been expertly "corralled" into the great room. <u>"Quiet please; settle down—because tonight I want to show you something artistically magnificent"</u>! Waiting while a heavy hush descends over the masses and a strategically placed lamp, beams across the "Blue light special", hanging bed-sheet, Van makes his move! Whipping away the bed-sheet with a flair that would entice an expert Toreador to exclaim, Ole—"<u>I present, the Village In The Dale</u>".

Instant recognition gleams in the eyes of his less fortunate compatriots. "Wow, you bought one of those expensive paintings at the mall gallery." Implying financial astuteness' at least. The host is quick to interject he also received a <u>free autobiographical book</u>!. "Boy, your smart" and underling praises, soon with other middle management quick to chime in. Now most crowd members instantly, pick up the flow rushing to have their compliments registered, proclaiming "you really know your <u>art stuff</u>"! Almost all agree, and what a great buffet too! A triumphant smile of satisfaction anoints, "the Lord of the Manner", as he "pontificates" over his wide-

eyed assembled subjects. Eager to thrust hand shakes in complimentary approval, as they surged forward.

Wait, there is some mumbling and downcast whispering occurring, at the rear of the crowd. Apparently the more professional segments seem to be "politely reserve". A few even leave while stuffing their pockets full of those little "demi sandwiches". Not wanting the evening to be a complete loss. Finally, an acknowledge serious collector volunteers a set of (unseemingly) harmless questions: "Does this artist hang in any important museum and not by self donation"? (A trick often employed by lesser artists to receive museum credits). Answer: Van Dope's radiant smile turns to a frown of bewilderment—and silence. "Let me be clearer. Do you know if he has any credits—like in a movie?" Answer: More silence, as Van's frowned face begins to drain to an alabaster white—matching the now strangled held bed sheet. Trying to soften the third question. "Has this gallery "hung" any other known important artists such as: Albers, Ernst, Hirst, Hopper, Hockney, Miro, Motherwell, Pollack or Stella? Anybody?"

A deafening silence descends over the multitudes. Van's face turns white, as the blood visibly drains to his lower extremities. A "gasp" emits from the uneasy shifting crowd, as he places a hand over his heart. Realizing his "fifteen minutes of fame" is evaporating and beginning to fade, he springs into action. Using that old C.E.O. stand-by routine, straightening his shoulders, thrusting his chin forward, Van Dope "bellows" above the anointed flock (they clearly unable to offer support) and visibly frozen in shock. "I can see that you all know nothing of fine art, and the rest of you can forget your Christmas bonus too"! "Good Night"! The stunned first nighters are apologetically ushered out by his embarrassed wife. Trying to save the moment she proclaims, "Van has been under a lot of stress lately". "Here, take another piece of chicken; it will spoil".

The following morning panic really begins to set in. Could that starving artist, that non-believer be right? Who invited that "jerk" in the first place? His wife sensing the ensuing fallout, and with the timing of a jewel thief, is safely on her way! She's decided to restore her own dignity and bury the pain of shame while charging copious amounts of money on her own art collection". Channel, Gucci, Vuitton, and

Cassini. She always loved foreign art, selecting it to adorn her 250 pound "petit frame". Explaining to the sales ladies, she is just a large size twelve. Frantically out of sight, knowing a good thing, they are busy ripping out the size eighteen labels and choking back tears of laughter. Soon proclaiming for all to hear, "these dresses were made for you". "Oh well. Then don't forget the "Armani" I put aside"! Confident, and knowing Van hasn't a leg to stand on, after last nights performance she heads for home.

Meanwhile, "back at the ranch", a sense of dread descends over Van. He begins to wonder what truly was "sliced and diced" the night before. Placing a panic call to the local museum, that's where he'll get confirmation of his artistic genius. Muttering, "those damn liberals are always wrong". Yelling into the phone, "I'm a board member, put me through to the director"! A mans voice answers, trying to calm him down. Van realizes the director also evades confirmation. Now his answers seem distant—hedged? When Van abruptly hangs up in a huff, the order to process his large donated check is quickly given—Board member or not! With the director's last words still ringing in his ears, Van also remembers that's what the gallery manager recited. "We are sure you purchased this because you like it". "Damn—Shit", he said that to cover his ass. Oh yes, also added with a parting wave and smile—"All sales are final, you know how personal art is, and don't forget your free book". "Free book my ass!", suddenly twenty thousand dollars of "liking" seems a little steep! "I've got to unload this "lemon", find another sucker." With his fingers walking through the yellow pages, one after another legitimate galleries politely turn him down. "No, we are not interested in your "cottage masterpiece", and those that are interested are only offering 10 to 20 cents on the dollar." "Are they nuts?" Wait he will donate it, that's it. Yes, Mr. Van Dope, you'll need an appraisal first for tax purposes—Oh, oh! Suddenly, twenty cents on the dollar is starting to look good! How could this be? It's a Communist conspiracy! Don't they realize who they're dealing with and recognize my great taste? Exclusive high price, pretty picture, expensive frame, nostalgia—I'm always right! (Van, guess again).

CHAPTER V

Revelation

You see this gallery originated, published, marketed, and promoted this outstanding artist, as the next great "White Hope". The only "snafu" here was someone forgot to tell the rest of the art world—what a major difference! Of course the customer was aided by the twin brothers of "ignorance and arrogance".

Haven't learned your lesson yet? Still hunger to pursue local talent? <u>Please place your next call to the nearest museum</u>, specializing in your <u>"field of dreams"</u>. Ask if they have a curator who has knowledge (example) on the "American Modernist Movement". Be brief and have your short list of questions ready. "Are there any local galleries or artists that exhibit or sell this style of art?" <u>There are never any guarantees that the information provided will lead you to the next Georgia O'Keeffe or Marsden Hartley. One thing is assured, the information received isn't profit motivated!</u>

Litmus Test

I might add there will always be a small segment born with "negative genes". Nothing we previously discussed will ever penetrate. There superior intelligence or in reality—dense psychic constitution. For these champions of ignorance and relatives of "Van Dope", I put forward this final "60 Seconds Over Tokyo" test. Ready?

<u>Test: Simply ask your "exalted self: How many great artists have emerged from your home town or local area in the past 10-20-30 years?</u> One other thing, if they found fame in the "Big Apple", and returned famous—that doesn't count.

The keyword here is <u>local</u> and your chances are this progression will apply to the next fifty years also. <u>If you wish to promote local talent and scholarships, then the education budgets for art and music, shouldn't he cut!</u> When it comes to established

artists and most major movements, big cities hold sway! The majority of "ground breaking" art movements, have originated in or near large metropolitan centers. Paris in the 19th and 20th century, England's "Independent Group" (after Tate and museum shows), clearly New York City, since the end of WWII, on the national scene.

The Big Apple reigns supreme! There are contending metropolitan areas such as: Boston, Philadelphia, Washington D.C., Chicago, Minneapolis, Houston, Los Angeles, Santa Cisco, Miami, Palm Beach, New Mexico, Phoenix and Flagstaff Arizona. These large cities are really "depositories" for great collections rather than originators of great movements.

All would like to lay claim as the center of the fine art world, in the United States. The fact remains that New York is the undisputed king. Here is why: There is an enormous concentration and breath of major auction houses, galleries, resident artists, and schools. Additionally, compounded with all of the allied "sister" art organizations such as: Symphonies, opera, and ballet companies, serious theater, off and on Broadway shows, T.V. production centers, major network stations, plus too many publishing houses to mention. These all contribute to the "competitive feeding frenzy" centered in the "Big Apple".

Serious young artists realize that if you can succeed in New York City, as the saying goes, "then you can make it anywhere". Two of the most important schools of the twentieth century art started, or developed, in the "Big Apple".

Abstract Art. New York City was the "Epicenter" with Jackson Pollock, Willem de Kooning, Robert Motherwell, and other big guns. Next followed by the explosion of pop art artists: Warhol, Kostabi, Haring, Basquiat, Rivers, Indiana, Dines, Wesselman, "Red" Grooms, Rosenquist, Scharf, and Ramos. All of these artists found fame and fortune in the New York scene.

Pressing this point, add to the previous mix these recognized and established styles: W.P.A. (Works Progress Administration), Ash Can, Modernists, Muralists, Regionalists, Mexican and Latin American artists, Cubists, and Surrealists. You see many great American cities are cultural centers, but as originators of new art it is still the "Big Apple".

The "dye was cast" early in the 20th century. Credit the famous "Armory Show of

1913", brilliantly organized by the igmatic artist, "Arthur B. Davy" for getting the ball rolling. Add the great infusion of immigrants from European countries, birth of the "Jazz Age", W.P.A. federal work programs and the art deco movements. With the advent of WWII, New York City became the (sanctuary) home to many of Europe's leading artists--CASE CLOSED!

New York City and the Dark Side "That Work is Placed"

Allow me to introduce you to some unwritten rules, when it comes to "the Art of the Deal" and some fine art galleries in the "Big Apple". So you're here to "crash" the party—you're sure of your own importance—you don't have "bad breath"—and you're "mommy" said you're old enough to spend your own money. There seems to be a problem, the gallery just won't sell you that choice piece of art, by that "hot artist" you've read about. Explaining that work has been reserved! Well welcome to the "twilight zone".

When a certain artist or group of artists attain "nirvana" or "hot" status, establish, etc., in the "Big Apple" the gallery or galleries managing that artist usually effect a buyers list. At the top are museums, corporations, or famous collectors, followed by the "neuvo rich" fighting to get on that buy list. Alas, then you! At this stage galleries "PLACE", their artists output. Museum sales and credits are important because the recognition of perceived "arrival", adds to the artists importance and pricing power— yes it's true! Of course when several galleries are fortunate to share a rising stars artistic output—(allegedly) they may even set similar prices initially until the market broadens out. Witness the past performance that had extended to the largest (and perceived honest) auction houses, located in New York City. Do the words "price fixing" come to mind—hmm? The unspoken goal here is to keep prices for the art market artificially up and the related big commissions to auction houses in parallel lock step. If the market softens, often at this point summoned are self anointed important new collectors, eager to establish their "artistic reputations". Dangled are the big names and sold are the grade "B" works, for huge sums. Yes, they may have a

real Picasso oil, however, Picasso painted hundreds of oils and they aren't all <u>created equal. Enter the "ego factor". Mine is oil, and yours is just a signed lithograph. Even from an investment viewpoint, I "got" news for you. That great "Lino Cut" by Picasso, percentage-wise has appreciated more than that grade "B" oil.</u>

Artists reputations rise and fall quickly in the New York City art market, especially in the case of the current "hot", "Book of the Month Club" selections. <u>By my best "guesstimate" and based upon decades of experience, around 75%, ten years later are only book marks.</u> To paraphrase, Andy Warhol, those ego-centric collectors have only one thing to show for their rush to judgment. <u>"It's fifteen minutes of (expensive) fame".</u> If you decide to drive in this terrain, you should be cognizant of the landscape.

Revelation

The New York City art scene is the sum of the "good, the bad and the beautiful". Need proof? Would you rather hang a proven great abstract S/N lithograph by Sam Frances, or last years forgotten "x" factor, "hot artist"? That's why bookmakers call these "long shots"!

Brave Hearts, Step Forward

Still can't deal with the "Big Apple"? That spirit of adventurism associated with the great unknown—burns within and motivates you? <u>The following suggestions are presented as a "best effort" and not set forth as gospel!</u> Areas and styles suggested are identified for your perusal and research. <u>Most are located outside of the "Big Apple", just like the coffee house movement from Seattle Washington. They do reinforce the</u>

<u>original premise, which is, go to the source area.</u> Here are some suggested areas to commence your treasure hunt. At least they're far from the maddening crowd! ($)

"The Highway Men"

Certain enlighten Floridians are long aware of this group, as for the rest of you intelligensia, here is a brief history. Art aficionado "Jim Fitch" is credited with originating the name, and "Gary Monroe" is the author of the book based upon "The Highway Men", Florida's African American landscape painters.

"The Highway Men", as they later became known emerged in the late 1950's. Acquiring their name because they sold their paintings along the side of U.S. Highway One ("The Federal", as locals call it). From Fort Pierce and Vero Beach, down to West Palm Beach, they promoted their artistic creations—literally by the side of the road! Never an organized movement, but basically a group of individuals trying to earn extra income, just to put food on the table, or painting as a means of relaxation. Credited with originating their style were two African American artists the first <u>Herald Newton</u>, soon after joined by another black artist named <u>Alfred Hair</u>. Both men came from "Black Town", an area of Fort Pierce Florida and attended Lincoln Academy High School. Later additional black artists who were associated with this style came from the Gifford Beach area of Vero Beach.

What Did They Paint?

Similar to Old Lyme Impressionists from Connecticut, their subject matter was located at hand: palm trees, swamp scenes, flora bunda, and various other native Floridian subjects. Aside from being field hands many worked at local building warehouses. Thus explains why most of the early paintings were done on gypsum board, a building material. Early original artistic labors were applied with an unrestrained fusion of wild color—common were paintings with orange and green

skies. As day workers in the fields, following the migrating seasonal farm crops, they also continued to peddle their art wares along side U.S. Federal #1. Sensing that painting was far easier money that baking under the hot Floridian sun as field hands, members of this group sought out a wonderful man, an established local white artist, Albert E. "Beanie" Backus. He became their mentor! A known local instructor and artist, "color blind" by all accounts when it came to art and education. Remember, this was the time of the turbulent fifties and I'm sure his actions were less than appreciated by some. That should have been the end of the story, left to drift off into artistic oblivion. However, fate intervened in the form of the state of Florida, many years later.

A questioner was circulated among schools, colleges, and various organizations requesting any information on creative groups that were indigenous to Florida. The "Highway Men" came to mind as a local "native" group! The fact that these folk artists entire opus featured Floridian landscapes, stylized with uninhibited bright colors, brought immediate focus on the state level. A school of art was recognized and began to emerge. When Gary Monroe authored his book entitled "The Florida Highway Men", this solidified there place in art history. Soon a few pioneering art dealers starting exhibiting "Highway Men" canvases at state fairs and after those local galleries picked up the scent. Previously canvases that hung over bars and summer rooms, originally purchased for $20 to $50 dollars now were selling in the price range of a couple of hundred dollars—overnight! <u>Current prices range from a couple of hundred dollars into the thousands of dollars. Could this be only the beginning?</u> For those who believe that history repeats itself notice the unusual similarity to the Connecticut Impressionists: A group of artists centered in a certain area, painting in a similar fashion (school), the use of local subject matter (Hamburg Cove vs. Florida swamps) and finally an original approach (uninhibited) use of colors. Even now this group is relatively unknown outside of Florida. <u>Remember, if it can happen with "Espresso from Seattle", then why not, "fine art from Florida". Did somebody say: deja vue?</u>

CHAPTER V

Western Art

Not new but growing. Oil up that "six shooter" and travel out to the "north forty" with me. A Texas or Oklahoma "oil baron" wouldn't be found dead without a western scene over his mantel. Oil, gas, gold, and R.E. added to beef has enlarged this buyer market. Now supported by several magazines, state and local associations, museums, galleries and guilds, this generic art is here to stay! Best grazing lands are galleries located in New Mexico, Arizona, Texas, Oklahoma, Wyoming and Colorado. I favor the first three states. A word of caution, prices are already high and resale outside of this area low. Not for investment.

The Artifacts of Art(Collectibles)

In the last chapter we will discuss this area in more detail. For now a quick explanation would be: it's like owning Chopin's concert jacket and not his manuscript or piano. Many objects associated with artist's lives and work become valuable. Proven personal items, letters, signed books, parts of a larger work. A recent example would be, Christo and Jean Claude's Central Park "Gates" project. ($) Fabrics, frames, brochures become "artifacts" after the art! This is a "trendy" growing area with collectors.

Pop Art of the United Kingdom

Your exclaiming not that again! Yes "pop art" with a twist! Never gave much thought to Carnaby Street or London artists, since the Beatles broke up? Well, "Vivan Westwoods" designs still lives in the heart of the "Brits", not to mention, ($) "Absolutely Fabulous". All four are collectible areas, however, let's hone in on U.K. artists—now's a great time to buy! Some Brits even claim they invented "pop art" and are the originators! True, only if you conveniently overlook the prior works of: Jasper

Johns, Larry Rivers, even selected works of de Kooning! Did someone bring up Walt Disney? Pop? Yes, they were there early on, and some of their artists were the best. What and who to buy? <u>Review</u> the pop art <u>form</u> which listed a "flock" of pop artists. Check the bottom section for U.K. artists. Many were associated with "<u>the Independent Artist Group</u>". The current generation has been labeled Y.B.A. which stands for "<u>Young British Artist</u>" (group). See everyone has a title, <u>more important,</u> <u>always collect where others aren't</u>.

Illustrative and Commercial Art

Bet you forgot artists have to eat too! So many great American artists started out as commercial illustrators to pay those darn recurring bills. <u>Thomas Hart Benton, Reginald Marsh, and Norman Rockwell just to name a few. My favorite gallery in this area is "Illustrative House" located in New York City or on the web!</u> Solid dependable and comprehensive in their subject matter, receiving my vote of confidence. Their publications include several excellent and informative books on illustrators. Place yourself on their mailing list, because they sponsor several auctions a year in this area, filled with "goodies"!

Movie Cells and Cartoon Art

I always felt that movie cells and cartoons where the first cousins to "Pop Art". Both not new, but in what I see as a "mid-life crisis" and a good time to buy! From California to Florida, there really isn't any "epicenter", only individual dealers. Check autograph and movie magazines. <u>One place so many forget to look for and often a rich harvest are "paper shows" (Ephemelia).</u>

CHAPTER V

Somethings Old and Somethings New

A closing thought on the Old Lyme Impressionists. First, if you chose to collect the Connecticut Impressionists, key in on the last generations. Harry Hoffman, William Chadwick, Guy Wiggins, Chauncey Ryder, and Roger Dennis. ($) Best buy in this group is Roger Dennis. ($) Also a contemporary, but not "one of the boys" is Ann Rodgers Minor. She was from the Lymes, and was doing her thing at the same time as "the old boys club"—an excellent artist.

Photography

So what's new? Collect photography? Of course, I know that! Now an established art form, however here are some trends to explore. First off black and white classic photography is safe and established! This may be your cup of tea. Moving on to newer areas check these out:

Studio and movie glamour photography. The period to emphasize is from 1930-1960, the glamorous years. ($)

"Large Format Photography", pictures beyond 20"x14"—up to wall size examples. ($)

Mix media, collage, and constructed (photo art) works. Here anything goes: a mixture of paintings and photo prints, assembled, cut-out, painted, etc. ($)

Digital photography? Some consider this area more of a technique than a creative effort—you decide. You will find it mixed in with some of the above mentioned trends.

THE ARTFUL DODGER

<u>Add South American and Central American to Mexican Art</u>

It's only smoldering now, but a generation ago you missed a "fire storm". Moving from Spain's: Gris, Picasso, Miro and Dali to Mexico's Jose Louis Cuervo, Orozco, Rivera, Sequeira, Covarrubias, Teledo, and Tamayo was a natural occurrence. If you want a change of diet, adding a little "spice to your life", here's what to do. You don't have to travel "south of the border" to experience your Chili and Salsa, because early practitioners set up shop in the "Big Apple". The Rockefeller family was always big on Mexican art, so names like Rivera, Orozco, and Covarrubias were promoted and familiar to American art collectors, before WWII. After the war they were joined by Cuevas, Teledo, and Tamayo. Now we are into new generations.

Early on the Rockefeller's promoted and sponsored Mexican artists and muralists. After WWII this area exploded! The now defuncked "Midtown" gallery always presented first rate Mexican and Surrealist artists along with W.P.A. artists like Paul Cadmus.

Currently both major auction houses* hold annual spring auctions featuring Latin artists. Today established is a coterie of full-time galleries specializing in this field. Would you believe the "Big Apple" finally has a "true contender". It's the Miami Beach Florida area.

With the influx of Cubans, Porto Ricans, Mexicans, Central and South Americans establishing residence in this local, a huge talent pool has developed. Energized by annual "art expo" style conventions, the greater Miami area becomes the prime location to investigate. <u>Notice I said "greater".</u>

Here's the skinny! Those aforementioned areas can be pretty pricy and picked over. From past travels I have found the best place to find old masters, and establish new Latin masters—(year round) is across #95 and U.S. #1, in the city of Coral Gables. ($) Here Latin art is a "way of life" and a constant festival! If you <u>think French, Italians, and Jews love art, here these citizens not only embrace art, but digest it for dinner!</u> <u>Bless them!</u> Coral Gables sets the bar high with a multitude of fine galleries. First Friday, a monthly event is town-wide and family style. Galleries business and free transportation all provided and you don't have to search far. Most of the important

galleries are located on the main thoroughfare--<u>Pounce de Leon Boulevard.</u> I do have a favorite gallery! ($) <u>"Check out" The Americans Gallery. Directed and formally partially owned by Dara Valdes Fauli.</u> She possesses solid expertise in Latin American art and is gracious to work with. Especially for the novice.

<u>Revelation</u>

In the beginning, God created Latin American art, "Taco Bell" and "Tex-Mex" came afterward.

<div align="right">-L.D.M.</div>

<u>Modern Art "Great Unknowns, or on the Edge"</u>

Personally I love modern art, but safety first. If your finances are limited, remember we preach value purchasing (first). In the next chapter we will give you the techniques to succeed. <u>After:</u> Impressionists, Cubists, Surrealists, Futurists, Modernists, Regionalists, Art Deco, WPA, Latin American, Abstract, Photography, Pop and Minimalists schools of art; <u>the waters are unchartered.</u> Go Slow! Remember I started off by saying: <u>"It's a large ocean so learn to swim."</u> We will discuss safe methods of collecting fine art, among them <u>"collecting backwards".</u> This method "gifts" you the luxury of time, allowing the art world to self-digest its own "fodder". Currently for example, "conceptual" and "installational artists" appear to hold sway with museums and large galleries. Don't forget they have the luxury of space to fill. Will it catch on, is it practical for the collector? As if most art is practical to begin with! Unless you're presented with a chance to convert your large guest bedroom into an exhibit hall for installation art, then in the words of a few "disenfranchise

losers"—<u>FORGET ABOUT IT!</u>

<u>Finally</u>

We have covered a lot of ground, exploring various trends and schools of art. I'm sure some to your liking and others you may want to regulate to the dust bin. Now it's decision time! <u>The moment to "nail down" your selections and employ those that satisfy your interest and artistic comfort zones.</u>

de Kooning. Original mixed media. Title: Devil on the keyboard. Work study.
Provenance: de Kooning family rainbow foundation to author.

Max Khune. Title: Original oil on board. Impessionistic pointillism technique.
Provenance: Auction house and former owner.

Thomas Hart Benton. Title: Old Farmer Driving. Circa 1922
Provenance, family foundation to the author

Samuel Gromppers. Title: The Senator. S/N lithograph

Grant Wood. Title: Signed lithograph. Provenance: Family Estate.

Miguel Carvarrubias Title: Samba S/N Lithograph

Paul Cadmus. Title: Artifacts

Calder Limited Edition, card sets from Paris Museum.

USA postage stamp sheet with artists portrait and mobile sculptures.

CHAPTER VI
METHODS OF COLLECTING
(ALSO ACCUMULATING CASH)

O.K. Sit down! Take a deep breath! Now <u>I want you to pay undivided attention, because this chapter is so important.</u>

First, let me compliment you on being a person of "class and good taste". I threw that in so you felt you've at least received something for purchasing this book! Drum roll!!!

I will disclose some of my successful collecting methods. We even present some honest methods of accumulating cash, short of "working" the dowager aunt."

This isn't an original thought. I am sure "Sherlock Holmes" or some great "Chinese Philosopher" introduced this idea. Paraphrased, or simply put, it is this: <u>"People often look, but seldom see (repeat that again, 3 times)</u>. Probably, it's one of the greatest differences between the <u>successful and unsuccessful collector</u>.

That thought "came home to roost", when my youngest daughter Laura, participating in a family discussion, turned and said to me: <u>"Dad your whole life is a collection!"</u> That moment of "epiphany", resulted in instant approval and spontaneous laughter from the assembled family members! All to eager to "assassinate Caesar". I remember turning and silently thinking, "Et tu brute!" So much for sweet young daughters. <u>Worst yet she was right!</u> Asking myself and reflecting on the idea, <u>why do people collect collectibles, even junk?</u>

I am not sure this is the answer, my perception may be slanted and reasoning fallible, <u>however collectors see and perceive value.</u>

Even collectibles become collectibles, because their life span was either limited, or it was easier to replace them. Finally they are often nostalgia oriented. In our lifetime we have shared "Mickey Mouse" to "Star Wars". History is accelerating from the "Atomic Age" to "Nano Technology". Not to mention a new generation of computers presents itself every 18 months.

Revelation

Summation, as we slow down to review our life, the world accelerates, to pass in review. Hence objects have lesser life spans!

-L.D.M.

One of my first collectible purchases was a 1967 Ford Mustang. To me, it had exceptional lines, and a well balanced design. Early on I realized well crafted objects, from radios to coffee makers, would always be cherished. They contain "a store of value". People appreciated them!

Unfortunately, I was forced to sell that beloved vehicle, when my family grew to three kids, a dog, a cat, and tropical fish. Talk about a population explosion. Years later I repurchased another 1967 Mustang convertible, only to have my oldest daughter "Robin" secret it off to college—where it "decayed". I knew her college education was good for something. Here is the point!

Even today that Mustang is a good investment, and will continue to appreciate in value!

Allow me to encapsulate three important learning points—previously presented, and you weren't even aware I was educating you! Call it stealth education!

1. <u>People look</u>, but seldom see!
2. <u>Classics</u> of any medium becomes "Icons".
3. <u>Good function</u> and design always will contain a store of value!

You may have forgotten, <u>but add these several ingredients, (more) directly related to fine art</u>:

1. <u>Size</u> of the collecting audience.
2. <u>Scarcity</u> and condition and importance of the art.
3. <u>Provenance</u> (history) and proof of authenticity.

I wish I had a dollar for every person who has addressed me with this statement, "Where do you find this stuff"? "I looked in the same place"! <u>Here is how it was done</u>, but just a short note <u>regarding finances</u>.

<u>Saving Cash</u>

Where do I find the money to purchase fine art? Start small and build:

1. Pocket change jar, plus add one dollar a day!
2. Sell old sports equipment, old tools, old best sellers.
3. Old cameras, military and boy scout pieces.
4. Bottle and cans; this might prove dangerous—wife's territory.
5. Tag sales, old furniture, kids furniture.
6. Start a vacation club (art club in disguise), etc.

<u>In other words "clean house"</u>; remember you're <u>moving up to the "Big Time"</u>! If none of the fore mentioned are acceptable to you, then consider a part-time job! This is so important:
<u>All of my fine art purchases were from my own disposable income. If mistakes were</u>

made, it hurt no one other than me. Most important, I had only to answer to myself.

"Let's Begin to Begin"

Presented here are two safe and easy concepts, for collecting. They have proven personally very successful. ($)

Some time after I began my educational career, I commenced studying for my security dealers license (NASD). My educational efforts at that time were directed toward teaching music and history subjects. Soon after passing my security dealer's test, serendipitously I was requested to help out the high school's business department. Personally interested in the challenge—I accepted. On the secondary level I taught courses in "Banking and Investment", plus "personal finance". Later when I began my fine art endeavors, I fell back on those (learned) principles of business. Now applying them to the collection of "fine art". Preaching, focusing your efforts, however all education is important. Sometimes secondary interests may end up as primary goals. Fine art and finances—hmm? Sounds like the chicken or egg routine to me! Let me explain!

"Value Collecting"

With "value collecting", TIMING IS EVERYTHING. Just as the stock market moves in cycles, so do schools of art and important artists! When a new school of art emerges, it is "fade wise", very expensive (sushi anyone?), and available norms, or standards are limited. So don't go there! Peruse or search for the "good stuff", that is out there already! Art history and great artists will revisit themselves usually announced with plenty of notice!

Major artists and styles always will be revisited because they have attained the status of classics—a standard of measurement. Like clockwork a deceased important artist will be celebrated on his one year anniversary of death! Then five years, ten

years, twenty five, fifty years, or one hundred years. <u>This is also a truth for the schools they represent. Now you have an advantage!</u> Which school will be celebrating a 25 year anniversary? <u>Example,</u> the school of "pop art" and the "chief artist" is Andy Warhol. Andy died in 1987, get ready, the year 2012 is coming!

<u>Buying your favorite artist:</u>

Buy in the "off" anniversary years, in the "valleys". These are your better value year.

<u>Example:</u>

Yr.1____Yr.5____Yr.10____Yr.20____Yr.25____Yr.50____Yr.75____Yr.100.
 $ $ $ $ $ $ $
Buy periods"$"...
Note, these years (Yr.),etc. Try not to buy during these years, as they are generally recognized as anniversary years by art publications and museums. For "Old Masters", years such as two hundred, three hundred, and five hundred years seem to be emphasized.

<u>Note,</u> *with "flagship artists" (Picasso—Cubism, Dali—Surrealism), they are so associated with their schools that the real first buying opportunity is usually in the 7th to 8th year.
 1987 Death
 A: Anniversary years
 B$: Value buy years, buy between the peaks!
 * First good buying opportunity

<u>Still not sure of this theory? Need more proof?</u> Purchase any of those national art magazines (Art News and Art in America), come to mind. Listed after the index, or near the last few pages, are exhibits, important notices, or "happenings" in the art

world. Including calendars of future and current exhibits. Yes, this will cut down on your lead time, because most schedules are only giving a year in advance. Check major museums because they are the ones to "clue" in on, and from their announced exhibits make your decisions.

Collecting Backwards

Not the mathematical type and you haven't the will-power to research art magazines or museums, for art cycles? Here is a variation of the above. <u>Pick a subject, school, style.</u> Need food for thought? Select one or two items from the following list:

<u>Example:</u> Limited editions of one artist, small drawings, work studies, water colors, mixed media work, W.P.A. artists, art deco artists, surrealists, abstract or pop art.

These examples listed are but a few of the many areas and possibilities available. Establishing parameters and guidelines are very important. Here is the most important rule for:

"Collecting Backwards"

Here is the number one important rule—PLUS!!

<u>When collecting in reverse, be sure to practice this only with important artists or movements.</u> This removes a lot of guesswork from the process, because reputations and artistic value have already been established. <u>Now the PLUS PART! Pick an area that isn't hot.</u>

<u>Example:</u> W.P.A. (Work Progress Ad) from the Roosevelt era—30, 40's, etc. W.P.A. artists aren't in at the moment—at least with the "yuppie" or "X" generations—not on their buy list—probably because the "Depression Era" is to <u>"grim" and traditional.</u> "Horrors" less they be reminded of their hard working parents, unions, or World War II.

<u>Great! In fact even beautiful, because the art value remains in such artists as:</u>

Rockwell Kent, Thomas Hart Benton, Grant Wood, Paul Cadmus, Reginal March, John Sloan, Isabel Bishop, or the "Soyer" brothers. <u>They become part of the second part of the equation. Their audience size and following has narrowed, but their value remains. You are now buying a beautiful work of art, at a reduced price.</u> ($) In financial circles the term would be: <u>value investing</u>. It may be a water color, oil, or drawings, just remember our original premise! <u>Always do this with a known established artist or school.</u>

Revelation

Just like American popular music and Jazz standards: "It Had To Be You". "I Surrender Dear" or "As Time Goes By", from the movie "Casablanca". You won't find them in the "Top Ten", however more than not, they will appear in the "top one hundred standards, of all times!

O.K. I surrender, and gave in to "a top one hundred list". I apologize! There is one slight (and) important difference. We are dealing with <u>a known commodity</u> here, and not an <u>unknown factor! Longevity, value, and acceptance have already been assigned—an not just presented!</u>

Recapitulation
(Recap)

If you will <u>combine those first two methods, you will have achieved the best of both worlds</u>. You're buying a known value, and you're also separated yourself from "the maddening crowd", leaving behind those ego driven prices also. <u>"You took the</u>

path less traveled", having more time to "smell the roses". Sorry I couldn't resist those roses! Bottom line, you gave yourself precious time and the lack of competing competition, to find those little "Gems".

This is what you will have accomplished. You've realized and discovered, with a better chance than "normalcy"; when that important school, and associated artist, will REAPPEAR ON THE RADAR SCREEN!

Moving to the "head of the line", you have purchased that artist at "rock bottom prices". Often foretelling, even before major museums have started announcing, "Retrospectives", repeat "Retrospectives". Revisiting those artists life work! To be successful, allow about three or four years lead time! Another indicator of "targeting" the right subject is if multiple, major museums, promote traveling exhibits. Of course if your purchase is on target, then your artwork will share in the resurgence added value and recognition!

<div style="text-align:center"><u>Revelation</u></div>

You have purchased those artists, when they were out of sight, but not out of value! There value remained because they are part of that "classic repertoire" of standards. In other words: PLAY IT AGAIN SAM!

<div style="text-align:right">-L.D.M.</div>

<div style="text-align:center"><u>Seldom Searched Areas</u>
<u>(additional ideas)</u></div>

Paper Shows (ephemera), for those of you who insist in a class presentation. I seldom bump into art collectors at these conventions. Beyond the post card collector,

there are poster dealers, map and autograph dealers. Some even have small drawings, or W.C. Remember, they are called Works on Paper!

Rare Book Dealers. Autographed books and book editions, by famous artists! Artifacts—yes. They are artifacts except when they also carry a small drawing with the autograph! Now you have a work of art, instead of artifact! I have a half dozen or so of these combination books—with the drawing authenticated! These often were easy to authenticate because the original owner seldom was more than 3 or 4 (collector) generations away. The dealer in most cases, bought from the original owners—source material: Picasso, Andy Warhol, Salvador Dali frequently gave autograph books with small drawings inscribed to their friends.

Add pop artists they painted on just about everything from clothes to wood doors. Just remember: An original work of art is an original, no matter where you find it!

Antique Dealers

Would you believe? Yes, I recently purchased from an antique dealer a great French art deco poster. It came from an estate in Newport, Rhode Island—great provenance. The catch was, he could have cared less about it because it didn't fit the colonial furniture make up of his inventory. It was a "throw-in" to his main purchase and didn't fit the normal cliental of his establishment. In reality it was an "embarrassment to him". That embarrassment turned out to be (for my few hundred invested) worth $12,000—dollars to me!

Revelation

Remember, one mans soup, can be another mans poison!

- L.D.M.

THE ARTFUL DODGER

<u>Collect a Collector</u>

Now here is a fool proof method, providing it is a good collection.

1. Have you ever noticed those little classified ads in the back of newspapers: <u>"Will buy entire collections for sale—Top Dollar Paid." (Signed) N. Dealer</u> Well, sometimes they do pay "top dollar" and more often "they don't"— because they work on a margin! The opportunity here is you can bid, somewhere in between wholesale and retail. Collectors are more prone to sell to other collectors, who demonstrate a love of those things they share in common.

 I remember a great series of purchases, when I was a young man, and just starting out. I met an elderly gentleman, who never sold art from his collection. We came together purely as art collectors, with a mutual love of fine art. When people approached him with requests to sell a piece, or make inquiries about a possible sale—he'd had a "six sense". He knew his art and the approximate market price—and sent them away!

 What the average dealer, forgot in his case, was experience and knowledge also went with longevity! He detested prestige buyers, or "quick buck" artists. I was so enthralled to learn from him, that I never dreamed he would sell his beloved art. When "out of the blue", certain items were offered to me, I was shocked. He quoted me a certain price—and I said yes!

 I still have those pieces. <u>One was a beautiful ink drawing by "Jean Cockteau". The other was a great Fernard Leger (cat) S/N lithograph based upon the "grand parade". He was the original purchaser—great provenance.</u>

2. <u>Art Clubs.</u> Already in existence, these people collect just like you. Sources are: art groups, local culture clubs, museum organizations, small town newspapers, local library announcement, and bulletin board—Network!

3. <u>Start your own group.</u> Place an ad in the "local gazette", under public announcements. "Anyone with a mutual interest in organizing and joining a fine art club please call: _____!

CHAPTER VI

Why would other collectors ever sell their art? Here are some reasons: <u>to fill a hole in their collection, to upgrade, they already have several examples of a artist, and may trade for another artist!</u>

A memorable occasion for me was the purchase from a *"ChiChi"* married couple's collection. Cultured until they opened their mouth, with the "affected attitude" that accompanied their personalities. When collecting was in, they were collectors and now they needed money! Of course what played into my favor was the <u>ignorance of their own art pieces purchased</u>. They raved about one painting—which was their favorite probably because they overpaid for it. The real prizes were those which they cared little about. A great "Arthur B. Davies", major pastel, and two American Old Lyme Impressionists. A small one, even thrown in for free—which I sold at auction for $1200—dollars. Of course I overpaid them for their "Jewel in the Crown"—again the supporting cast was the real "Oscar" winners!

Revelation

<u>The road to success often is not paved with flowers.</u> (De Sarro – deSarreaux mother side family motto).

-L.D.M.

CHAPTER VII

The Legend of de Kooning, Thelonious Monk, "tripping with" eBay and Dead Case Tales"

Sometimes art is where you find it. The story behind my acquisition of an original de Kooning work of art was more unusual than my attempt at being the worlds "funkiest", white, blues piano player.

In the late sixty's de Kooning's publishers were steadfastly trying to persuade "Willem" to create colorful lithographs, that would showcase his strong use of color. Previous production efforts in this area were directed toward etchings, usually on shaded (colored) paper. These works although interesting, didn't compare to the dazzling use of color, brilliantly demonstrated in his paintings. At some point, it was noticed that de Kooning liked the music of contemporary black jazz pianist, Thelonious Monk. "Monk" was an "iconoclast" like de Kooning, breaking all of the accepted norms, plus a creative force in his own right! Soon de Kooning's interest in "Monk", for reasons unknown, led to his first published multi-colored, limited, edition lithograph. The original edition of seventy five sheets sold out. Later, a second edition of seventy five pieces also S/N, with the words "Rain Bow Devil", was published. Amazingly with a carrying price of $9000/10,000 dollars these also sold out, demonstrating the importance and popularity of de Kooning's work.

In preparation for the original edition, de Kooning worked on six original paintings, consisting of oil on gouache, on paper. All were similar with the exception of different colors. Allegedly, as the story unfolded, de Kooning selected the painting, which he preferred. This was in opposition to the publisher's preference, to select

composite colors from the combined works. A disagreement ensued and de Kooning took this favorite piece and left. The remaining five paintings, unsigned were consigned to the shadows of time. <u>The selected painting, possessed and favored by de Kooning, surfaced as inherited property of his family's trust, "The Rainbow Foundation".</u> The Rainbow Foundation was initiated as a collaborative effort with other famous artists, to raise scholarship money, from the sale of donated works. The proceeds went to promising art students.

"Back to the Hunt"

"Once upon a time", about a decade later, I was drawn to an article in the "New York Times" art and theater section, on "Modern Art". Where upon the conclusion of the article, inserted was short "cryptic" message, stating that an important American artist's work was available "for sale" from a foundation. Along with that information, a long distance number was provided.

Having a stout heart and soul, I dialed that long distance number. A cultured and slightly "affected voice" answered. Judging from the intonation he carried an obvious distain for "humanity". With the confidence of an "executioner", he announced that I would have to take a test, even before I knew who the artist was! Gloatingly he also said, "a dozen or so had already failed". Such inducement instantly inspired me to add my name to his list of "failed dregs of humanity".

<u>Question:</u> Do you know who "Thelonious Monk" was, and can tell me anything about him? Annunciated in the same patrician voice!

<u>Answer:</u> American black, modern jazz piano player, who at various times in his life resided in New Jersey and New York City. Composer of many jazz standards: "Monks Tune", "Round About Mid-Night", extensive American an European tours. Pianist (flat fingered) technique made use of flatted 5ths, 7ths, minor 2nds, and open dissonance, etc. Fifteen minutes later, there was the sound of complete "unconditional surrender" and amazingly the effected voice disappeared. When he finally regained his composure, now in a less tenuous voice, he ventured to ask my

background. Happy to report, my background was more complete and accomplished than his! Well, I passed that test, and purchased a real authenticated, original "Willem de Kooning", famous image painting of "Monk". Of course it came with a wonderful history and provenance.

Later, as it was relayed to me, the one pre-requisite for a sale, unknown to the "tester" (me), stipulated that the buyer had to know the background of the subject matter. Remember, this was de Kooning's first colored lithograph (work on paper), and the second edition, S/N, by a Connecticut publisher, sold out between $9000 and $10,000 dollars a sheet. Now, would you like to venture a guess as to what the original is worth?

Again, education and background made the difference! That night when I turned in and said my prayers, I also "thanked" de Kooning for being a "jazz aficionado", and complimented his wonderful foresight and taste.

Georgia on My Mind

Internet auctioneers are a product of the twentieth century—a whole new ball game! Foremost is eBay. Free and accessible on your home computer. Testimonials aside, along with the trash listed, also presented are some real artistic treasures. Just "click" on the category of art and amazingly great names like: Picasso, Dali, Miro, Dega, Monet, Benton, Bellows, Warhol and Wesselman fill the screen. Paralleled with these great names are their listed works. Oils, watercolors, mix media, drawing with "groupings" such as modern, art deco, pre-1900, W.P.A., etc. Here is the enjoyable part; some of these listings have opening bids that are less than a "six pack of beer". Can you see yourself at the next "X" generation/yuppie social gathering: "I was in the market today for a Renoir, I just missed out". Talk about name dropping. Conveniently, you forget to mention it was the "blue light" special on eBay and opening bid was just .99 cents.

Wait, have I forgotten to mention one small caveat? "O.K., here it is. Most of the listings are without provenance or authenticity. PLEASE read the presentation

material very carefully and email questions. Even with doing "due diligence", certain dealers are adept at circumventing direct questions, or their answers. <u>Asking questions is so important that I consider this to be the second "golden rule". We will discuss this first commandment later!</u> Be it known, the better dealers take pains to document and describe the level of authenticity, using accepted terminology of the trade. Here is a brief list of assigned labels and my understanding of those definitions.

1. <u>Authentic</u> – The real thing—no question a guarantee.
2. <u>Attributed to</u> – We believe but don't have the proof.
3. <u>In the school of, (technique)</u> – (Example, Impressionists).
4. <u>In the (Italian) school</u> – Nationality from a country.
5. <u>After</u> – Following death.
6. <u>After an artist</u> – Working in the same style of an artist.
7. <u>Provenance</u> – History, (AKA) – title search and ownership.
8. <u>Documentation</u> – Often interchanged with provenance, papers, dates, receipts

Here is a listing example:

"Monet" <u>Attribute</u>	<u>An original, signed water color, the subject is lilies.</u> Signed "Monet" and attributed to him. Condition as follows: no in-painting (touch up/paint over) spots. Purchased at a tag sale. It looks like a Monet, however without proof or papers.
<u>Translated</u>	It smells like a duck, it looks like a duck, however we don't know if it the right duck—hence, "Attributed".

<u>Now it is up to your judgment! Check the signature, style, colors, subject matter, date, age and appearance of the canvas, etc.</u>

<u>The artwork may present both a buying opportunity and a simple solution. If you have additional knowledge that the seller doesn't have, and your winning bid represents a small percentage of the real value, having done due diligence with your check list (mentioned), "then go for it".</u> One last thing! Please don't use the rent

money. I really don't favor your wife calling me (to complain) in the middle of the night, proclaiming it was my fault your marriage failed—use discretionary income.

Question: Why would anyone sell a work of art by Jackson Pollack, for a small percentage of its real value?

Answer: Returning to the bottom line; the lack of documentation and history which equals "provenance". In plain English—PROOF!

Remember, I previously mentioned that proof was extremely important. I'll wager over half of the present day collectors still do not read or document their purchases. Price, former owner, date, condition, medium—that's how provenances are born! If you haven't a record system here is an example of mine.

Record Keeping, AKA "Dead Case Files"

To prevent the historical facts of your artistic acquisition from being "lost in space", here is my suggested two step solution. A file and form system.

Number 1, files: My option is to purchase "pocket folders", not file folders, but pocket folders. Next, place every bit of information in that pocket file: checks, dates, owner statements, "descriptions of authenticity", even your notes and questions. Get the idea? You will thank me in ten years, when you try to sell that piece. Don't skimp, a pocket file for each individual art work. On the outside of the jacket, label and list important quick reference items, artist name, school, and medium. Finally, as time permits add or take photographs of each purchased piece. A visual record may be required for insurance or theft reasons. Beyond that, you may later need to sell or publicize your art collection. It just boils down to: "One picture is worth a thousand words". O.K., sooner or later you knew I would get around to that old cliché! Again why is provenance so important? Just check art work on eBay; those pieces that are presented without history and those that are accompanied with documentation. Being lazy may mean the difference between $5,000 dollars and $500,000 dollars.

THE ARTFUL DODGER

Revelation

Is proof important? Hey someone did that for you. Remember that "thing" called a birth certificate? To think you thought that only dogs had papers!

-L.D.M.

Category Form

Why then the need for a catalog form beyond file pockets? A listing form allows you to inventory artists by school, style, period and medium, etc. In essence it is your own catalog ransom. Files are individual compellations of facts, figures, and historical documentation. Should your fine art collection contain a dozen surrealist works and your confronted with the situation having to look up a specific work, then it becomes far easier to flip through your catalog index. Just try pulling dozens of file pockets until you find the right one! Here is the other tip. Place each school, style behind a master colored index card. Example: Latin American Art (red card). Finally, unite them in a three-ring notebook folder or on a computer disc if you possess typing skills.

THE DEMAIO COLLECTION

ARTIST: No. _____

SCHOOL STYLE:

TITLE AND DATE:

MEDIUM:

SIZE UNFRAMED:

SIZE FRAMED:

SIGNED:

CONDITION (SUBJECTIVE):

PROVENANCE:

Before addressing the urge to splurge—be a detective!

Authenticating artwork needn't be that impossible. Just look to your nearest large public library. Other important resource centers are museums, and art colleges are another available source. Hi-tech oriented? Online searches and private entities (some charge) such as: "Ask Art", Ask Jeeves, Yahoo, and Google will furnish you with information, pointing you in the right direction. Then there are richly illustrated biographical works on sale in major book store chains. I found "Borders" to have a more extensive selection and "Barnes & Noble" better discounted art books—you decide! Catalog ransoms are compilations of "known" works. If you're fortunate enough to tap into one for a specific artist, it will eliminate a lot of searching. Albert Fields, whom I met several times prior to his death, explained he had inspected thousands of pieces by Salvador Dali before assembling his catalog. Even today there

are more Dali's to discover! Catalog ransoms aren't always the last word, however if you able to match or discover your artwork, by image, physical description and dates—then that piece of art work increases exponentially in value. A word of caution! <u>Be wary of catalog ransoms often "singularly" published by individual galleries. They have a vested interest in authenticating their own works, as opposed to others. I am personally aware of works of art, still with their original owners that were rejected because of "turf wars" forcing some legitimate dealers to sell artwork with the following disclaimer: "You have a month to prove this is not an authenticated work, please furnish your experts opinion (which also needs to be provided) for a full refund".</u>

A short while ago, on an online auction website, I became interested in an Alexander Calder large original circus drawing. It was perfect in every detail—except one. Physically, it was exactly half the size of the original circus drawing. Personally I suspected some kind of mechanical reduction and trace over. Presented as authentic, it received a frenzy of bids. My frantic emails to the auction house weren't acknowledged. "Bingo", the Calder sold for "big bucks". Ten years from now that owner is in for a surprise when he precedes to a sale! Go to that resource center and so your homework, because it is one thing to take a calculated risk, but another to be out faked by a smooth presentation.

I dwell on this subject because it is a two way street, and the major difference between $5,000 and $500,000 thousand dollars. Yes, the picture you're looking at (the Black Dali) my nick name, was an effort of two years research, to gather documentation. As popular and important as Dali was—his artwork has been copied and forged like no other great artist. This itself is a testimony to Dali, however a nightmare for both collector and dealer.

Documenting my Dali, meant working my way through two years of interviews, publishers, and originators of this project. This information was additionally substantiated by photographs, and signed affidavits of personal involvement. Next, I computated and formatted the material into a complete history of ownership. The final result was a work of art that now is listed in the "Dali Catalog Ransom" by Albert Field.

CHAPTER VII

"The Black Dali" front cover photograph and continues to generate history, because of its provenance, unique color and mixed media construction. Featured in numerous articles and exhibits in New York City and Monaco. In fact, the "Black Dali", "The Chalice", "Cup of Love, Holy Grail" or "Tristan and Isolde", all names attached along the way, became the featured article in the premier issue of the "Dali's Investors Newsletter", edited by Paul Chimera. In a second major article revisited by other Dali experts, they also verified my findings and this pieces authenticity! There was one small erroneous fact stated. The author claimed, "I stumbled across it". Actually I found it stored in a garbage bag at a friend's house. I also paid him a "hefty" amount of cash for a then undocumented work of art. I really shouldn't complain because Salvador Dali, after all was said and done, received the grand total of $35 dollars for his creative efforts. Do you mind if I come around and visit your garbage bags next week?

That Poor Lady Has Been Waiting All This Time!

Recently I found a Georgia O'Keefe watercolor, yes, you heard me. This work of art had such an important ownership provenance, so much so, even I became suspicious. I approached and requested assistance from two major museums. Both major museums assisted me in collecting the historical background information that reinforced the ownership provenance. I won't speculate on the value of this piece, but I will disclose that sometime ago I handled a smaller water color example (approximately 6"x9"), and the selling price was just below $300,000 dollars. My Georgia is almost double size of the represented one.

How and where did I find it? Where else, on that great American institution—eBay. Actually it had been delisted removed when I came across it. Why hadn't someone else located it before me? Let's see—first it was listed in the wrong category—under antiques, then the next "faux pas" was Georgia's name was misspelled. "O'Keefe" rather than "O'Keeffe"; double "eff's". So number 1, a computer search wouldn't have turned it up, incorrectly spelled. Two (2), it was listed

with antique furniture. Listed correctly, it probably would have "garnered" a couple of dozen bids. Tracking down the bewildered owner I negotiated a purchase—there were no other offers. It is now my proud possession—See! Leave no stone unturned!

Returning to Georgia on My Mind

My artwork was unsigned, however it displayed some script—handwriting, which was authenticated against several known examples. Georgia had dated and written the location on the bottom of the sheet. Placing the artwork's origin, at the right location and in the right time-frame. The fact that this piece wasn't signed did not detour me one second. From research I ascertained that many of Georgia major paintings often were unsigned. Alfred Stieglitz, her husband and business agent, at the time of his death, was in possession of over 800 hundred of Georgia's artworks! Compounding the issue, they were uninventoried, many unsigned, others traded or gifted away to members of his circle (Marsden Hartly, Arthur Dove, W. Sheiler) even his long time friend the great French sculptor Rodin and he exchanged artworks. Georgia was living out west and Alfred was in New York City when he passed, leaving a huge quagmire for Georgia to deal with because Alfred wasn't the best of record keepers to begin with.

I stress the record keeping and researching because of a humorous incident I watched on eBay. A "poor" fallen collector was "pressured" into buying a "Dufy" water color for a large sum of money only to discover his purchase was a well done fake. Yes, it was a beautiful proven forgery! Whenever he passed by the "Dufy", dwelling on the extravagant loss of capital, he became emotionally ill. Aggravating him to the point of placing the painting, "his wife had to have" on eBay. Feeling that painful reminder would at least be out of sight. On the balance, he hoped to recoup a few pennies on the dollar, for what he considered expensive wall paper.

The listing retold his tale of woe, explaining his great fake masterpiece. To his surprise the combination of honesty, a well-done forgery and with a bit of luck achieved a sale of sizeable money. Yes the "good guy" rode off into the sunset this

CHAPTER VII

time! <u>The lesson to be learned here is: "All art, and even eBay are a two way street".</u>

<u>Revelation</u>

In the art world it is either feast or famine, but if you're careful, you still can enjoy the buffet.

-L.D.M.

<u>Here Is the Golden Rule</u>

<u>When bidding on any item on eBay, WAIT, repeat wait, until the last half hour before placing your first bid.</u> This allows time for a second bid, before the listed item is closed out.

"DO NOT", repeat "DO NOT BID EARLY". Here contrary to reason and reinforced by this old adage, <u>"Only fools rush in where angels fear to tread"</u>!

Currently, as I put pen to paper, there are two supreme idiots, who have discovered an item I have been quietly observing for two days—a "Basquiat" art piece. These two mental giants have already amassed eleven bids between them with their on-going bidding war. I'm sure they feel that their strong display of betting prowess has scared away all others. "Quite contraire mon ami". Their self-centered arrogance has only succeeded in attracting attention for these "legends in their own minds". Completely unaware of their real status, the sharks have started circling. One shark has jumped the item by a hundred dollars bringing their display of stupidity to a momentary halt. Of course they were really successful in drawing attention to themselves. Now the intelligent players are patiently observing from the sidelines, as these "two bit" players are soon sliced and diced, into "chopped liver". A few heavy hitters announced their presence by moving the piece to over two thousand dollars. Again a show of ego, before intellect. What happed to "Moe and Curly"? You know the "dynamic dual" who possessed a combined score of 250, on their high school S.A.T.'s. They are still cursing

their "dumb luck"—well, at least they got the dumb part right!

Revelation

This is neither a request to sell, nor a solicitation to purchase eBay stock. However, with a fool born every second, and so many attracted to eBay—THINK ABOUT IT!

-L.D.M.

The Final Wrap

When the professional "Ebayer" spots even a few hits, in any category, like sharks they begin to circle. Soon other sharks pick up the scent. Now those pious with inflated egos and attitudes are soon to be put out to pasture. It's spring cleaning time!

Having analyzed many betting patterns, of high number winners, I was amazed to discover, most weren't specialized, or even art lovers. In many cases, and for the lack of a more socially accepted term—compulsive gamblers come to mind. Remember that listing which sat there for two days, with an opening bid of $77 dollars and then ending up going for over $3000 dollars plus. The winner was a lady whose three previous winnings were cheap cosmetics. No, don't reach for the eye drops, you read right! Low priced items under thirty dollars. This "feminine mystic" had numerous successful bids—(anyone for "Gamblers Anonymous"?) Again, our "nano second losers" achieved over fifteen bets and the winner just one! This player, was actually drawn to the "Moe and Curly" show because of their multiple bids.

CHAPTER VII

Revelation

You see there is wisdom to that old saying, "Better late than ever"!

-L.D.M.

CHAPTER VIII
Art for Adolescents (OK, Grown-ups too!)

Working with young students promoted and deepened my passion for educators and the education profession. As a group, youngsters bring unbridled motivation to subjects that capture their attention. When my inspiration and motivation merged for this project and the writing process actually materialized, it was of major importance (for me) to include a collecting section for young adults. Also needed was a brief curriculum of ideas for parental guidance. Philosophically, my innate emotion proclaimed "If it works educationally—use it!" Call it brain washing, or casting a wide net, if it attracted the adolescent "psychic"—great! On the plus side, parents should also be aware of the fact that students involved in the arts, score above average on the I.Q. tests. Look at it in this light, when kids are involved with a project they're not sitting around planning to "hoist" the local convenient store.

"Children of the Korn"

A very long time ago, on a return flight from Florida, I remember "pontificating" to my wife. Americans have a unique and growing culture". Precipitating that remark was my momentary investure in an article on "Walt Disney", "Mickey Mouse" and movie cells. Most in-flight magazines are a compilation of advertisement directed toward a captured audience, however this magazine included a redeeming article on collecting movie cells and that rang a bell!

Why? Because they were "one of a kind", American originals. In all honesty, I had come to the same conclusion, at least several years earlier. "See", I told her! She responded with the usual blank face bewilderment "So"? "So", I told her, "I started collecting them, as a side interest for our kids." Of course her repartee was expected; "You're the biggest kid I know, who are you kidding?" The word, "infidel" registered across my mind. Quietly, I had already acquired original studio drawings and animation cells—"Hah"!

My early collection included: Mickey Mouse, Donald Duck, Bugs Bunny, Elmer Fudd, Pinocchio, Raggedy Annie, and Mighty Mouse. Later I added Batman, Star Trek, and even Dr. Suess. Actually the very first character I purchased at auction was a original India ink page of "Spider Man" comics. Which I gifted to my son "See, I told you, good taste ran in the family"! Personally, I always believed that the cell and cartoon art movement preceded and prepared Americans for the "pop art" movement. Chronologically it really was the first "pop art" school.

Revelation

Well, what's so bad about this idea; if you can't own a "Degas", what's wrong with a "Disney"?

-L.D.M.

Here was your chance to "buy American"! Of course I follow my instincts, but more important being a pioneer, I literally expended pennies on a dollar. "I'm on first so who cares who's on second"?

The important thing here is the subject matter! Now I agree that cells, cartoons, and comic books have attained the status of a large and often expensive market. However the implied lesson here is that this "market" may also be used to entice

youngsters—acting as "gateway" material to more serious art!

New animation and cartoon figures are generational. ($) Yesterdays, Bugs Bunny, and Elmer Fudd are today's Muppets and Sesame Street, Shrek I & II, Harry Potter, Batman, and Spider Man, live on. Cult followings among young and old adults have developed for: Lord of the Rings, Star Wars, Star Trek, and Titanic. Even Beatles "groupies" seem to live on, and on—

Posters

Movie posters are still around for all of the previously mentioned characters. <u>One key point, when purchasing movie posters, purchase the large-full size version.</u> These will have a seal or stamp on the "shrink wrap", identifying them as original official movie posters. Disney and Warner Brothers posters often double in price, in just a few years. Especially if the movie was a mega hit. Condition is important so refrain from bending. Mint condition (for sale value) is important, so confine your purchases to those that aren't ripped, torn or bent at the corners. If purchased for an investment, leave the original wrap in tack. Poster framing may be achieved with inexpensive, off the shelf, frames, <u>however don't forget to remove the cardboard backing provided. This should be replaced with acid free mat board,</u> which is an available item at any art supply store. If you're lazy, and not removing the cardboard you won't need to pose the <u>question—"What's for dinner?" The acid chemicals in the cardboard will leak into your poster, destroying them</u>.

Do you have a teenage daughter interest in dance, ballet, theater, or drama? Start her off with a performance of a Broadway musical, or Christmas presentation of the "Nutcracker Ballet". Can't go to the "Big Apple"? Wait until the original cast road show visits your town, and purchase <u>autograph cast posters</u>. They will never be worthless.

<u>Can't afford to collect posters?</u> Then give a thought to collecting the free "hand bills" in the lobby! ($) Normally the display stand is near the ticket booth, so it's always better to go at a non-performance time. Recently I've noticed that hand bills

are showing up on eBay with increasing frequency. When certain items begin to appeal to a segment of any audience, gaining a following, value or a market value follows—it's the old story: "supply and demand". Usually free, easy to frame and most contained the identical artwork on the production posters.

"Baby Boomers and Yuppies"

I acknowledge that this portion of our book is directed toward youngsters, however lets aim a few choice words toward the "BB&Y" groups. Most museums are holding social events, once a month called: "First Friday", "Second Tuesday", or "First Night", etc. Call it what you want—they are great mixers for all ages. When you attend these functions, stop in the museum store. It is kept open for your patronage and we promise not to tell the football—barbeque crowd! Often these functions will be timed to the exhibit of an important artist. Here is something to think about—artists <u>often attend their own exhibits, out of gratitude to the museum and their audience. ($) Buy the poster or exhibit's catalog—usually $30 dollars or less. Politely ask the artist for an autograph,</u> "Shazam"!—your souvenir has increased in value often by as much as a couple of hundred dollars. Especially if it is a famous and well known artist.

Today, well preserved autographed posters, signed by "heavy weight" artists, such as Matisse or Picasso, often bring fifteen hundred dollars, or more. Again, depending on their image and condition. <u>So you want to register a protest, "Too little too late". Here is another "window of opportunity".</u> Both Andy Warhol and Keith Harding are recently deceased "pop artists". If history repeats itself, look for autograph posters by these two "pop" icons to appreciate.

Often we "Yanks" tend to be isolationists, however if you were to ask the "Brits", about "pop art", they will declare that they invented it and will furnish you with a selection of artists some from an entourage called the "<u>Independent Group</u>". ($) <u>They will sight names such as (Sir) Peter Blake, Allen Jones, Richard Hamilton, Pauline Boty, David Hockey, and Edwards Paolozzi.</u> In the same period <u>Italy</u>

contributed, Erico Baj and Mimo Rotella, or course in that vein include the German pop artist, Claes Oldenburg. Yes, the Brits really do have somewhat of a claim. Where would "rock and roll" be without the Beatles and the Rolling Stones? Of course you have to balance that with the likes of prior American artists: Jasper Johns, Larry Rivers and an early "pop" artist often everyone overlooked William Copley—(U.S.). "The pop of" "pop art"—and not the Boston artist, the other same name, from a hundred years earlier.

"Vox Populis"

Right now, the best values in pop art may be found with the English pop artists— aforementioned. Why? They "maintained and practiced what they preached" by printing large signed and number editions, often into the thousands. Credit these with holding true to the philosophy that pop art should be in the reach of everyone's pocketbook!

We have already expounded on posters, so if you're too old ($) for a Disney collection, then the ones to collect are museum posters. Museum posters furnish you with a double value. Easy record keeping (most are printed with a date and location), and important 20th century artists such as: Sam Francis, Robert Motherwell, Larry Rivers, and David Hockey. These are but a few that have promoted limited edition exhibit posters. Again when signed, their value often will exceed a plate signed edition. ($) The golden age of movies and radio spanned the decades from the thirties to the early fifties. In this period think of the schools of art which attained recognition (W.P.A. artists)—Works Progress Administration. U.S. government's answer to employing thousands of workers, also employed hundreds of out of work artists. Europe enjoyed the avant-garde Surrealists school. Art Deco designs stretched into Modernism, which saturated everything, from architecture to furniture. Posters of planes, trains, and especially steamships by "Cassandre" immortalized the ocean liner (Normandie). Movies such as "Casa Blanca" and the "Maltese Falcon" coupled adventure and fashion. Of course, in fashion Coco Chanell and Lisa Searprarelli had

their own private war. Coco lined up movie stars and Lisa favored artists such as Dali. Coco favored "black" and Lisa love her "Hot pink"—even artifacts by these two grand dames are now sought after. <u>Hint, fashion art and photography may be an important area to look into.</u> ($)

Finally there are several recent collectable art areas that span the teenage to retirement period. The Japanese cartoon and digital character images of "Mariga" and "Tsubash"! They tend to be violent prone and teen oriented—parental supervision is suggested. There are another two that deserve monitoring.

One on the B.B.C. (British Broadcasting Company), and the second on our Public Broadcasting. Already both have attained cult status.

<u>Absolutely fabulous", the B.B.C. "telle" comedy series cleverly written by and starring Jennifer Saunders.</u> The twist here is the adults are "wasted" and the kids are straight! Americans may relate to Jennifer, as the voice of the "mother-in-law", in the movie "Shrek II"; and her comedy series which runs intermittently on our "Comedy Channel"—it's "Brit Pop Art". Pictures, posters, artifacts, props, etc. are already a cottage industry in the U.K. ($)

A special mention should also be made of her "Dafy" blond T.V. sidekick. In real life she is Dame Joanna Lumely (former Avenger and Bond Girl). In real life Joanna is married to the serious British conductor Stephan Barnes. Why bring up Joanna—she possesses an exceptional understanding of Spanish Renaissance artists. No dumb blond here!

O.K. Not up to "Crossing the pond"? How about looking right in our own backyard? When Mystery Theater first appeared on public broadcasting, I was immediately attracted to the novel Victorian graphics that ran along side the opening and closing credits! ($) These were created by (the late) illustrator Albert Gorey. With some creative detective work, a few years before he passed away, I tracked Albert down to his Cape Cod home. This resulted in two long delightful phone conversations with this enjoyable raconteur. Albert directed me to his book and gallery agent's store, in mid-Manhattan. Informing me that they handled lithographs, etchings, and signed first edition illustrated works by him. Of course the rest was history. I purchased a small first edition collection of signed books, posters, and

lithographs. One item I purchased recently was auctioned off for six hundred dollars on eBay. Edward Gorey has also become a cult industry and his whimsical works are becoming increasingly sought after! ($)

Revelation

When art snobs "pooh-pooh" illustrators they conveniently forget about Thomas Hart Benton or Norman Rockwell; both were originally illustrators. Not to mention de Kooning—he started his artistic career as a house painter. Here are some of my favorite illustrators: Dean Cornwall, John Groth, and Steve Dohanos.

CHAPTER IX
TRAVELING AUCTIONS, "ROAD SHOW"
ANATOMY 101
HISTORY

This chapter should be titled the same "old shuffle" or "smoke and mirrors". If you haven't been invited or received an invitation to attend this type of auction, allow me to demonstrate a "probable" scenario.

These traveling art auctions are a recent phenomena, appearing in the past 30 years. For the most part the <u>works of art are authentic, usually with little redeeming "artistic"</u> value! By far the presentation and framing are the real show! However the intended impression (implied) is that the "fine art" presented, being so magnificent, should really be hanging in the Louve, the Tate, or Metropolitan Museum of Art. It poses the question, "How did all of that great art escape"?

Scenario and Background

The <u>majority of these traveling circuses are normally co-produced with a local civic group</u>. Selectively targeted are women's organizations. This not only ensures a large turn out, but induces pressure to buy, based not upon artistic merit, more so because "it's a good thing". A second inducement is location. Location is important to create the illusion of class. Often selected is a slightly upscale hotel, or community center, and the "clincher" is announced, "free refreshments"! So here we have a

bourgeois evening out with free refreshments. How can anyone lose? The refreshments amount to a mediocre bar cheese, and a lesser value table wine. Of course this induces the "proletariat", to the illusion; they certainly have arrived, and are now part of the "artistic conocenti".

Act I
"In the Beginning"

Opening act, begins with one or two respectable pieces. Limited editions of great artists—with decent framing thrown in. Noticeably, these have decreased in frequency (ex: Miro, Dali, Picasso, Moore, coupled with Caldor, Warhol, etc.) A signed and number lithograph by "Picasso" is brought forward—at real market value of several thousand dollars and promoted with a high "reserve price"—bottom price. Achieving the desired effect of sending the unsophisticated audience into "silent spasms". In their minds this price equates into an entire years mortgage payments— of course nobody bids—there probably all "choking on that cheap cheese"! With a slight of the hand these pieces are all deafly removed "ALL ACCORDING TO PLAN"!

Act II

The second phase is quickly initiated, with a cordial compliment to the audience before someone goes into "cardiac arrest". "How smart they are waiting for the real values"! Again the same artists are returned, with one slight difference—plate signed editions. Keep the "big name"—stamp the artists signature. Not to worry it's still a "Picasso" and presented at a third of the price of the signed price—what a savings"! Of course this awakens the audience. It's like having a 60% off coupon at the local supermarket. Better yet you now have a second chance to achieve instant status, and recognition (at the "cold cut" counter)—"she bought a Picasso". Being recognized by

your "peer socialites", and local used car dealer for buying that real "Da Vinky". (Advice)—you'll get a better deal with the used car dealer. The bidding is to $900 dollars—"Sold to that lovely (faux) bejeweled lady, with the "boa"! This treasured piece—what a smart consumer"! Guess what? All according to plan!

Revelation

For your educational benefit, you should be aware that "plate signed" works on paper, often may be "open editions"—no set number, and stamped into the thousands! Possibly only a few editions by Picasso, Dufy, Miro, or de Kooning have a published set number! Example: de Kooning S/N 250—pen/pencil signed. de Kooning plate signed 250 stamped signature. If you want an excellent and authentic plate signed edition, reach into your pocket and pull out a dollar bill or a "Euro" and read whose signature was "engraved" on the bill! Repeat, plated signed are engraved-photographic but stamp signature from plates!

"Act III
"The Name Dropper"

Pay attention you're not home yet, here is the next "booby trap"—no, I'm not going near that cliché!

The Auctioneer Continues

"How about a great Renaissance or Romantic period artist? "Both known and

famous"! The audience thinks, wow, you can't go wrong with those! (Yes you can.) "We have a <u>special</u> on <u>Goya</u> and have I mentioned the <u>Rembrandt</u>?" A timid and half "cuckolded" husband, two car payments behind, quickly "blurts" out to his wife's embarrassment, "Is it authentic"? "Yes, of course it's authentic", the auctioneer bellows back, in his most "sonorous voice"! Thereby achieving the desired effect of "silencing the lambs". Continuing, "May I also commend you for holding out for the real good "stuff"—"patience now".

The bidding commences, and this time it is spirited! Back and forth, back and forth, higher and more until the anvil drops "sold", he's thinking (to that mousy brunette) for $1,050 dollars. The audience "gasps". "Aren't those <u>brunettes</u> just so smart"? The auctioneer continues "yes, this beautiful small 3-1/2" x 5-1/2" with real Rembrandt etchings was sold to that lovely lady"! Of course the "blond bimbo" who came with paycheck escort, has just delivered a kick under the table, (good by N.F.L. standards—for fifty yards), to her pained filled escort. Smiling through her teeth, "you fool, you let that little treasure get away—you didn't even bid! I will fix that! I lost a real "Rembrake"—JERK! "Worst of all, to the "mousey brunette" from the flower shop"!

<u>Revelation</u>

Another pitfall. Great old masters are mentioned—giving the idea of credibility. <u>The heavy play is on the name</u>, include Renoir in this group. <u>What was brushed over are words such as "Later, after, multiple states"</u>, etc. <u>Again the artist is long gone, however his plates are working harder than your mother-in-law's "uppers"</u>. Remember what happened to "Paroniasi Plates"—later editions were stamped into the thousands! <u>You want to hear the words, original, first state, and signed.</u>

CHAPTER IX

Act IV
Grand Finale
"coup de gra"

Still haven't taken the bait yet? Remember the "Trophy Wife", or "Bimbo du jour" fuming because she feels left out, hasn't anything to show for sitting through three hours of the "culture club". So here it is, <u>"THE CLOSER"</u>. American citizens also know it as the "Red Alert", or dangerous "Terrorist" warning!

Speaking in a reverent hush tones, carefully adjusting his tie with stone cold sobriety, then waiting for complete audience silence, he begins: "Yes, there are those among you who have truly missed out on the great artistic treasures presented here tonight. We do so regret that your desires are <u>"pained with emptiness"</u>—a cultural void! Therefore we have decided that you're such a great art loving audience, that you deserve a final, <u>last "gone for ever chance"</u>, to join the ranks of "art aficionados". Therefore we have saved <u>"the best for last"</u>!

This is it!

The stage has been set, here it is, <u>"the last call for alcohol"</u>. He has captured the audience's attention and now no more bathroom passes will be issued. This is serious time! A nervous "hush" ripples through the entranced audience. The entrapment pressure will be increased especially for the several empty handed, and headed, ladies of the evening. They have "no culture" to show for an evening's work. Now the auctioneer interrupts briefly with a timing that would make a "rock" drummer gasp. He thanks the dowager peer sponsors, strategically seated amongst the audience. Hopefully mandating their efforts to raise cash for the: One eyed, lame, "save the world's endangered cockatoos organization" is a success. He begins his spiel:

"Because this masterpiece is so important, we have reserved a special announcement for the winning bidder! That winning bidder(s) along with their great art treasure will appear in the society section of the "local social sheet" photographed prominently alongside of the president of the "Endanger Worlds Cockatoos Organization".

"My God did you hear that? Did you hear that stupid? The blond bimbo mutely

screams into her escorts now fractured ear drum. Our picture could appear in the picture section of the "local social sheet"—subconsciously implying existent fame, nirvana, and recognition amongst the "jaded" leaders of the community. Not to mention, "doing it for the birds". Yes, instant status will follow—all in "one fell swoop". God is truly great.

"Priming" the audience by casually mentioning their awaiting fame, a half dozen times, the house lights dim—right on cue! Suddenly a pin spotlight illuminates the easel work of art. A hush reigns over the audience. Now the great profit of 21st century art, begins as the room sinks into complete darkness. Beginning slowly, usually by stressing the technical aspects of this cherished art piece.

"Magnificently, this work of art was printed upside down, underwater, on a 16 color press—using a revolutionary, digital bubble refracting, lithographic etching, mixed media process". On hand made toilet paper." (You get the idea.) The blond bimbo can't contain herself—"hook necking" her escorts head close to hers. She screams in his ear—"Did you hear all of that good stuff?" Of course not. Nor is he understanding any of it. "This is a real masterpiece—darling—it is so marvelous!" The auctioneer continues, "Of course it was rumored that Isadora Duncan—ask for an artwork similar to this on her deathbed". Several women choked back tears. The spotlight intensifies! The auctioneer continues: "This piece was inspired by "Mona Lisa". Actually, it was by his ex mother-in-law, for lack of child support payments…the "Coup du Gra", begins:

"We have been selling a ton of this "great unknown artist". This is your chance to jump in, "on the ground floor". Pausing, and looking directly at the "Bimbo"—"He is selling like hotcakes in Crotia, Dubai, even in lower Micronesia". In fact it is always any country, other than the one you are in. Preferably those not regularly served by international communications—continuing:

"And look at this adorable snow crested cottage with frosted windows aglow. Notice the spiral smoke curling up from the ice capped chimney. You can almost look into the white glazed windows, and cozy up to the glowing hearth of the fireplace—Bundled children playing with their puppy dogs. Shouldn't that be you in this picture? Well, the next best thing is to own this great work of art—make it your

CHAPTER IX

personal treasure! Be the <u>lucky one to take it home!</u>

Dry eyes are now replaced with moist ones. Mascara filled eyelids begin to smudge, erasing the natural beauty of the assembled feminine majority. Returning to his attention grabbing commandeering voice he bellows: <u>"Now do you ladies really want to be left out of this artistic chance of a lifetime?"</u>

Quickly reviewing, "snow peaked cottages, spiral smoked chimneys glowing lights, warmed (though unseen) hearthed fireplace, puppy dogs, (and the killer) snuggled "jammie wrapped" toddlers" (also unseen). "This is all presented in a truly original, <u>exclusive</u> limited signed edition print"! Who needs gift wrapping, (smiling), because we issue our own certificate of authenticity—what more could you ask?"

<u>Every nostalgia, tear grabbing clichéd image, that could be revisited, and manufactured from the "library" of past human experience has been evoked.</u> Remember, this is referred to as <u>"Greeting Card Art".</u> It is based upon <u>nostalgia—</u> tried and true! Never <u>creativity</u>! Remember those men—now the silent minority, long having been stifled, and told that they were: uncultured, uncouth, cultureless animals, are abruptly awakened. These reduced humanoids having remembered what happened to the last of their specie, who dared to speak out about "authenticity"— He was last seen being flayed with a "Gucci" handbag and dragged by his ear, into the "black abyss" of the last row. Eyes lowered in total shame and unconditional surrender. It's a good thing those ladies came prepared and are wearing their "maxi pads", because they will be tested tonight! Not to mention their elitist escorts, who are about to experience for the only time in their life, the "Vulcan Death Grip". Silently applied to their forearms!

Now he is on a roll! "How can you miss? There are only 300 hundred, hand-signed pieces W O R L D W I D E!!! This number grabs the used car dealer's attention, because he knows numbers! "This exclusive edition is all but sold out, (until next auction), and only a lucky few will take home this masterpiece"! Now the used car dealer, the last hope of "mankind", must rise to the challenge. Reflecting, three hundred into three billion people—wow! That's less than the production run for a 1936 "Bugatti" roadster—the auctioneer continues with measured restraint:

"How can you go wrong, with our opening price of $350 dollars, Euros, etc. But

for this intelligent crowd of art lovers, we will begin the bidding at $250 dollars", so no one will be left out. Remember, it is for a good cause! (Never leave out the guilt complex routine). The words hardly fall from his mouth.

When hands fly up, men shout bids by kicking wife's—not to be left out! "Unknown and famous". There is an oxymoron if there ever was one. More bids ring out: $300, $350, $400, $500—"Technical aspects to die for". $600, $700—"printed on toilet paper", $750, $800—"only 300 world wide"! A bidding war breaks out by the two legends (in their own mind), the "Bimbo" and "used car dealer". $900, $950, $1000, (gasp) "An artistic treasure" $1100, $1200, $1300 dollars, now the audience in shocked silence. "Who will be the one and only star of the art world tonight?—the lucky one"! $1400, $1450, the ultimate "Vulcan death grip" is applied. "$1500—going once, twice, three times to that beautiful lady in the front row and her handsome escort". Inwardly smiling the auctioneer surmises that white faced, blood drained checkbook, has just been "financially decapitated". "Yes these two folks deserve a "big hand", as newly recognized patrons of the art world"—what a team!

Screams of delight explode from the admiring crowd. Back slapping, bra popping exaltations of ecstasy surge forward from the "save the birds" ladies club. Having just realized 20% of the sale—over $300 dollars the auctioneer who is now considered the uncrowned disciple of modern art, raise his outstretched arms—a "hush" ensues over the milling crowd. Unnoticed the blond bimbo, in this moment of distraction, sweeps the remaining bar cheese into her large handbag.

Art history has been made here tonight. These two intelligent connoisseurs of fine art have stepped forward, breaking new ground, and having created an unforgettable moment in our history. Truly, they are the stuff legends are made of, having made our world a better place to live in"! "Good night all"! A thunderous applause ensues, as he fades out of sight. Smiling to himself with the satisfaction of a successful "chicken thief", he acknowledges that another "turkey" has been plucked and "Thanksgiving" is still a month away!

CHAPTER IX

Revelation

This "prized edition" was most likely done, "in house", by a contracted artist who will receive $10-50 a sheet. The original artwork is sent off to their printers and framers, at an estimated $15 dollars an hour. Now throw in the materials for a total cost of $25-50 dollars a sheet. The auctioneer may be salaried or receive a bonus of 5%, based upon the evening's dollar volume. Now the "bird ladies" cut (a percentage) is for 10-20% of the winning bid. O.K. $300 dollars. We have a total probable cost of $450-$500 tops!

Breakdown: Artists $30.00 a sheet

 Printers $15.00 a sheet

 Materials & Framer $50.00 a sheet

 Auctioner $75.00 (5%)

 Ladies Club $300 (10-20%)

 $475.00 high estimate

 $237.50 low estimate

Wait, the "winning couple" isn't done yet. They have to pay the "auctioneer fee" (10-15%) and a (probable) sales tax of 5% on the sale. Their cost is $1500 plus $150 equals $1650 to "the house" and 5% tax overall to the government. $1725 total. If we use "high end" expenses ($475) from $1650—assuming the "Feds" or "Inland Revenue" are given their amount, the profit amounts to $1,175 dollars. Realizing 200 to 300% for a dubious piece of art. Not bad for a slow night.

Reviewing the Line Up

O.K. I apologize for over indulging myself with some "slight exaggerations", describing these traveling auctions. The truth be known, not by much! Therefore to

minimize the inflicted pain, <u>I will "recap" the highpoints of my narration, with some</u> <u>additional material added.</u>

<u>Order of Performance</u>

1. <u>Good works and signed numbered editions are introduced and removed very</u> <u>fast!</u> If the reserve isn't made, this "happening", often is scheduled at the beginning of auction. The primary <u>purpose is to cover the advertising</u> <u>promotions</u> that are used as an audience draw! The hook!

2. <u>The image of creditability is continued by introducing great names with plate</u> <u>signed additions</u> or later (deceased) multiple after states. Note, these shouldn't be confused with living artists, or artists during their lifetime who rework their original etchings. Normally when artists rework a plate, if is done with the purpose of improving the image. Examples by Paul Cadmus, and Isobel Bishop come to mind.

3. <u>Overdue emphasis placed upon the technical aspects</u> of the work, and not the importance of the artist. It is more important that a work by "Matisse" is hand signed, catalogued listed (authenticated), in good condition, then by a unknown artist on hand made paper! <u>Another little gimmick thrown in on</u> <u>occasion, is the "created emphasis" on a low number of high number of an</u> <u>addition.</u> This may have been more important a hundred years ago when lithography, etching inks, and tools were more primitive. <u>Forget it</u> now. <u>Better</u> <u>it is a clean impression.</u> There isn't any added value to a piece being a numbered "1" or "10".

4. Famous purchases ("Isadora Duncan" celebrities). This only <u>implies</u> <u>importance by association,</u> and does <u>not add value to the art.</u> Because a person is famous, he may have been given, or purchased that artwork for promotional reasons. Technically it is just the reverse of the idea, "guilt by association". <u>Here is a (partial) short list of knowledgeable "illuminates".</u> Known for their artistic ability or knowledge <u>of fine art collecting:</u>

CHAPTER IX

a. Anthony Quinn – (late)—actor, artist

b. Sylvester Stallone – actor, artist

c. Elton John – musician, collector – British

d. Dennis Weaver – actor, photographer

e. Dame, Joanna Lumly – actress, U.K. Spanish art

f. Steve Martin – actor, collector

g. John McEnroe – sports, M.C., modern art

More on this later!

5. <u>Cultural countries are linked to current art work.</u> Evoking the cultures of France, Italy, England, Spain, Germany or Russia. Again this emphasized "greatness is by osmosis". All countries have cultures. <u>The idea a great culture always guarantees a great artist is foolish.</u> An artist may be "rotten", and he may not even be from Denmark. My apologies to the "Great Danes". <u>Again it's the artist and not the area.</u>

6. <u>Nostalgia.</u> All art is emotional! However, when they use every <u>"tear jerker image"</u> known to mankind, as <u>the greatest</u> invention since <u>"sliced white bread"</u>—"forget about it". The word to remember here is <u>creativity</u> and style to a lesser degree.

7. <u>The Great Unknown Artist.</u> Yes, all artists start out as unknown—how many have you found in your lifetime? Even famous artists by today's standards—had to fight to create recognition. Time and time again, before their importance was established, their gallery and museum credits were long established—few were overnight sensations.

Do you really believe that these traveling road shows have, or have been known <u>to discover "The Lost Treasure of the Incas"</u>? To put it bluntly, the next real unknown artists? For them it's just "Zuppa de Giorno". The soup of the day presentation! <u>More than likely their great work was "created" in-house—or simply some bought out, second rate artists edition.</u>

Returning again to that old saying <u>"Buyer beware".</u> Well I hope you enjoyed that free wine and cheese, because the rest was all—Smoke and Mirrors.

CHAPTER X
GRADUATION
"PASS IN REVIEW"

Let's see, have you learned your lessons? How about a quick review? Sorry, once a teacher always a teacher!

I. Types of Collectors. There are probably several million collectors in the U.S. alone, and they collect everything from finger nail clippers (exotica) to fine art. When we dissect this mass constituary and separate the so called fine art collectors into their own sub-set, what survives is an even smaller minority of real fine art collectors. We realize the actual competition is thinner than you think. Have confidence, "Art is for all"!

II. Rules of the game. Do your homework, provenance, authenticity, condition. All contribute to the resale price so keep records. This is so important! Save those bill of sales, notes, and dates in file pockets. Develop your own quick reference sources of books, catalogs, bibliographies, auction, and internet sites.

III. Limit your field of dreams. Avoid my largest mistake, or you'll end up with your own museum. Pick and stay within your chosen confines. Select a school, style, artist, or even a medium. Pop art, abstract art, W.P.A., art deco. You may have infinity for water colors, pastels, portraits, figurative art—so many to choose from. Feeling brave? Jump into a newer area (although not suggested) like "minimalism" or Installation art. Then you may argue is "Christo", and the Central Park "Gates project" really installation art, on a large scale? Why not wait

until next year he may decide to wrap the "Empire State Building".—Just kidding! I applaud his creative efforts.

The last few decades have seen photography come into the artistic mainstream. Remember Marilyn Monroe and that famous stance of hers, on a New York City sidewalk grate? White dress bellowing up! This photo is a "modern classic"—as far as I am concerned. O.K., call me a "dirty old man", because I purchased an original negative B&W photo to go with my "Ansel Adams" and "Man Ray" originals. Forget it, Marilyn is not for sale!

IV. When, Where and Where Not to Collect! Remember these methods of locating and finding art! My philosophy of preaching "safety first" for the novice!

 1. Cycle Collecting. Schools of art tend to act like stocks. They rise and fall, depending upon their anniversaries, popularity, and exposure. ($) Certain anniversaries of great artists entice museum curators to schedule exhibits. One, five, ten, twenty five, fifty and one hundred year periods—are the most popular. Be a contrary collector and purchase in between those historic markers, and you'll receive more value for the dollar—"Bang for the buck".

Example

Yr.1_____Yr.5_____Yr.10_____Yr.20_____Yr.25_____Yr.50_____Yr.75_____Yr.100.

 $ $ $ $ $ $ $

Artist: Rest in peace (1 yr) (5) (10)
You: Study, plan & select. Buy* Buy* Buy*
*Purchase in between these year markers!

 2. Collect backwards. Can't be bothered with keeping time? Museums and curators often will exhibit established artists and schools—important movements! They have identified the artwork for you. Focus on smaller works by the same artists, or limited edition graphics! ($)

V. Collect other collectors. Start out by assembling your own group. Find other collectors and collections. Often collectors may choose to (barter) trade and not

CHAPTER X

sell. Especially if you both have multiple works that either could use. "Birds of a feather collect art together". Serious collectors will often sell to people who have experienced the same "joys" as they do! "Soul brothers and sisters". Take that extra step—check out references and leads! I acquired the de Kooning because he liked "Thelonious Monk" and I was acquainted with both artists—which leads me to the next point.

VI. Be a serious "private eye"—Investigate. Take that "fork in the road". Robert Frost wrote it, and Johnny Carson used it! It helped to make him rich! Small schools have a way of becoming National Styles. Especially if they are near large populated areas. When promoted by official agencies, city, state or government, their chances for success increase. This phenomenon extends to all of the arts. Miami has South Beach, and art deco festivals, art and architecture. Seattle Washington claims "punk rock" and "coffee houses". Of course surviving "Hippies" remember—San Francisco, at least those who went through "rehab". Are the "Florida Highway Men", next? Officially recognized by the state of Florida and area dealers, could it be they are just below the horizon nationally? Connecticut impressionists can command prices beyond six figures; even third tier artists bring excellent prices. History has a way of repeating itself and with the arts it's referred to as retrospective or revivals. Is this market ready to emerge?

VII. Artifacts and satellite collections. Notice the word "artifacts". I wonder where that came from. O.K. you are here by given "civil dispensation" to collect by association. Sister artifacts having to do with famous artists. These often will provide us with an insight into their lifestyles. ($) Especially if they mark a time, place, or event. Already mentioned are posters (the safest item). They are the best combination of art and artifact. I was fortunate to purchase from a friend and fellow student artists (a signed poster), by Keith Haring. Returning to school and speaking on the danger of Aids, knowing that warning was too late for himself. He designed and autographed a special poster, some with small drawings for fellow students. That event is marked in time and space, again provenance! Here are some collectible areas often overlooked. No pocket change, so you can't

buy that available original Warhol? <u>How about a self autographed book or letter?</u> <u>Many famous artists not only autographed books based upon their work, on many occasions they added a small drawing.</u> I know of four artists who were famous for this and did it by the dozens. <u>Dali, Picasso, Haring, and yes, even the "Campbell Soup"</u> kid himself—Andy Warhol—and guess which sketch was his favorite? You "betcha"—a Campbell soup can! At your next social foray, you may announce; I am the proud owner of an <u>original</u> Dali's work of art. Hey, it qualifies (if authenticated) even at two inches tall! ($)

Forget "absolute vodka" posters, unless they're signed. <u>This next mentioned item already has a small army of followers, "Swatch Watches".</u> Remember those cheap old solid state plastic devils? Well they're back—and not even in "basic black". I own a great limited edition autographed (on the wrist band), Sam Francis piece, complete with presentation case. The case also displays small examples of his works. <u>There is one pitfall with collectibles. Even if someone proclaims</u> this is "Keith Haring's" pizza stained tie—don't bet on it. That doesn't go for "big" in the art world—<u>let alone licensed open editions</u> of: Tee shirts, towels, handbags, bathrobes, or sunglasses. You get the idea. <u>"Open edition", simply means never ending—on going! Stick with autographed books, letters, photos, and dated materials. Those are your safest bets—example, posters!</u> ($)

VIII. <u>Support your local museum—Join!</u> Be a "first nighter". <u>Want a great poster collection? Autographed no less? Attend open nights of the exhibit, and ask the artist for a courtesy autograph.</u> Your poster just tripled in value. Especially if your artist is already nationally recognized. <u>On certain large important openings, museums will publish a S/N limited edition lithograph.</u> Being a museum member usually entitles you to a discount, autographed posters are real winners and remember provenance—keep the receipt. ($) If your forgetful—not to worry these works are dated and placed for you! A more recent innovation are museums issuing limited edition posters, lithographic printed, on "rag content" papers.

IX. eBay and net surfing is just a click away. <u>Remember the most important basic rule, that I refer to as "The Golden Rule". Never bid early! Wait until the last half hour and leave time for a re-bid.</u> Park your ego and don't get "sucked" into a

CHAPTER X

bidding war. On occasion when I lost (yes it happens) three out of four times I placed an early bid because of attendance required for a business, family, or funeral. When I returned, it turned out to be my funeral—I lost! <u>When it comes to web surfing, practice the usual searches then take the next step. Try common misspellings, nicknames, or alternate categories like artifacts and antiques.</u> "Ask Art" is a great information site.

X <u>Art is where you find it,</u> and you probably won't know a soul there—good! Remember to visit these unusual places: <u>paper shows (ephemera), book shows, and of course antique shows.</u> ($) Yes, be that "Stranger in Paradise", or just "Cross the pond"—on eBay! Remember the "Brits" were innovators in pop art too! ($) One way or another, the bottom line is <u>to try and get to that source</u> area if possible. Western art isn't found in abundance in New York City's upper east side, or even behind Lincoln Center on the west side. A word of advice—<u>"Go West Young Person!"</u> Notice the unisex statement. I have to deal with two daughters. Your computer and phone will bring you to the best Western art galleries, "be thee" in New Mexico or Houston, Texas.

What Not to Collect!

Reviewing these hard earned lessons will save you both time and money. Revelations <u>are important as they balance the equations! In other words, don't be chump, save that change!</u>

Here are the Minuses

A. <u>Stay away from collecting, "Greeting Card Art".</u> Cutsy animals, cottages, bonnets in the breeze and little lambs. If Mary had a little lamb, it was probably a "Cesarean", so forget this style. If you choose to persist, then <u>go to your local greeting card store. There they "care enough to sell you the very best".</u>

B. <u>Don't collect at traveling auctions—or so called license auction liquidations.</u> The pickings are thin. Where you read the fine print listings, the catalog are

111

rampant with terms such as: plate signed, attributed to, in the school of, after (15th state), and tied to big names like Renoir or Rembrandt.

Revelation

> "Remember the big print give us, and the small print takest away".
> -Attorneys, Do, We, and Cheatum

C. <u>Don't be so fast to collect the next great down the street emerging artist.</u> This can be a difficult situation, especially with so many good struggling artists. Recently, I purchased some beautifully executed original black and white photographs from a local photographer. Wonderful subject matter and choice. In the follow-up meeting I suggested ways of receiving national exposure at associations with major galleries. I pointed out that important schools of art, in the past century, have originated in large metropolitan areas, for the most part. Available exposures from important syndicated publications are also centered in those sites. Referencing my local photographic discovery, notice I had refrained from proclaiming: "Here is the next great messiah of black and white photography". Help your local artists in positive ways; don't hawk them for self-engrandment!

Revelation

> There are many impresarios, but few emperors.
> -L.D.M.

CHAPTER X

<u>Conclusion</u>

<u>Great art that has established creditability always is original in concept, and not just original in technique.</u> Museums and curators (often blindly), support important movements—so pay attention to those trends, and not the "Van Dopes" of the world. Presented are a few final words for the novice art collector: <u>"follow proven methods of action that achieve results"</u>. Educate yourself, research your area and be ready to act when the curtain goes up!

<u>"Flash, Breaking News"—Update!</u>

Returning to those "101 great collectors"! I am sad to report the worlds greatest collector of "shoe lace paintings", was recently found deceased in his posh home. Medical examiners attributed his suicide to depression resulting from the "revelation", few if any were interested in acquiring his extensive collection of shoelace paintings. Reported to be the largest in the world. The investigational report went on to reiterate:--"In silent protest and in his final act of artistic rejection, he chose his favorite pair of shoe laces—to hang himself. These were described as: Ruby red and gold, made with multi stranded tightly hand-woven nylon materials, with a Teflon coated serrated edge, and displaying the image of the Brooklyn Bridge"—End!

I couldn't help thinking, some people—just know how to go with class. You probably thought I was going to be negative again? Well you certainly deserve a reward for surviving this unusual learning experience; now turn to the last page!

CERTIFICATE OF REVELATION

Declaration: Being of sound body, and questionable mental ability, I have purchased this tome, because I chose to advance beyond that universal rule:

"I bought it because I like it!"

You further acknowledge: To apply your own brand of madness with the tools and methods provided, and to accept all revelations as gospel. Including those with misspellings.

The final Revelation

"Nothing succeeds like success."

Candidate:_____ Date:_____

Director of Revelations, Leonard D. DeMaio, K.S.M.A.

FIN

Breinigsville, PA USA
17 June 2010
240116BV00003B/1/P

9 781432 752491